# BANFF

## THROUGH TIME

Banff Preservation &
Heritage Society

AMBERLEY PUBLISHING

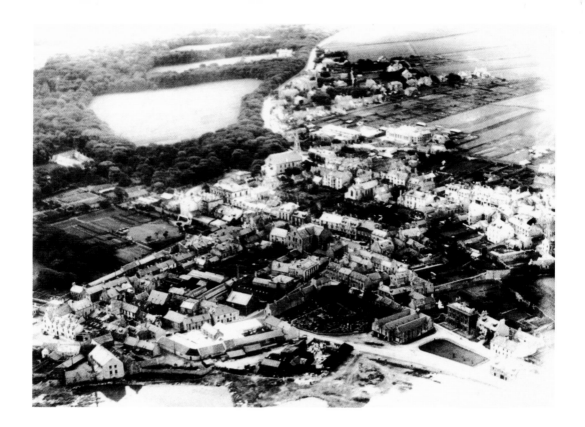

First published 2012

Amberley Publishing
The Hill, Stroud
Gloucestershire, GL5 4EP
www.amberley-books.com

Copyright © Banff Preservation & Heritage Society,
2012

The right of Banff Preservation & Heritage Society
to be identified as the Author of this work has been
asserted in accordance with the Copyrights, Designs
and Patents Act 1988.

ISBN 978 1 4456 0302 5

British Library Cataloguing in Publication Data.
A catalogue record for this book is available from
the British Library.

Typeset in 9.5pt on 12pt Celeste.
Typesetting by Amberley Publishing.
Printed in the UK.

# Introduction

Banff is a Royal and Ancient Burgh, and very largely looks the part. As you come down through the woods behind Macduff, suddenly there is the bay and the fine little town rising behind it. You see that the town is on two levels – Low Street and High Street of course – with gardens plunging between, and to the north, beyond the grounds of the castle, there is a sea town and harbour. You would have to walk around the town, rather than drive, to appreciate that the heart of Banff is still largely Georgian, with more listed buildings than any town of its size in Scotland.

Banff is centuries old. The Royal Charter was renewed, not first given, in 1372. There are walls still there that surrounded the royal castle during the Scottish Wars of Independence. You don't have to look very far to find seventeenth-century work, but you are surrounded by the eighteenth century. This was a town where the gentry for 30 miles around had their winter townhouses, a very lively and genteel little place. There was a strong sentimental attachment to the exiled house of Stewart, and the economy of the town was built on smuggling. Later there were real industries: we made stockings, though that trade died with the Napoleonic wars, and then we exported herring, though that trade died out with the Russian Revolution of 1917.

The town was squeezed between two earls: Findlater and Fife. The present Banff Castle was a dower house for the Countess of Findlater, and on the outskirts of Banff is Duff House, the magnificent baroque palace of the earls Fife. As neither could get all his own way, they fell out with Banff: Lord Findlater (by then called Seafield) went off and built Cullen, and Lord Fife built Macduff. Macduff prospered, and Banff stayed genteel but rather down-at-heel. It was a town of half-pay officers, and ladies living on small fixed incomes. That is why we have so many old buildings: at the time we could not afford to replace them. To this day, some Banffers will declare that it is a 'town of tinks and toffs', but then leave their listeners wondering which they are.

Then comes the part of the history where photographs reveal Banff through time. We need not sum up nineteenth- and twentieth-century history in the introduction because the pictures tell the story so much better. Do bear in mind that Banff is an old place. Many of the 'then' pictures show buildings that were around a generation before the invention of photography, and part of the pleasure of this book is that lots of them are still there in the

'now' photographs too. There were terrible losses, because Banff, like other places in the 1960s, wanted to be modern. So we have pictures of what we have lost. Occasionally the building is still there, in decent condition, but its setting has changed. Sometimes, however, there are happy 'before and after' pictures of restorations of buildings that were down on their luck.

It is great fun to look closely at old photographs, because there are details there that the photographer would never have noticed at the time, but we can leap on. And the formula of having 'then' and 'now' on the same page means that, with the modern picture in front of us, we are not trying to visualise things we see every day, but never examine closely enough to remember.

We are proud of our stock of old photographs of Banff, but they do not tell us everything. There are streets with no old photographs, and there are events that made perfect sense to the photographer but puzzle us. We admit the gaps. Still, the book has been great fun to work on, and we hope you will share our pleasure in Banff as seen in photographs through time.

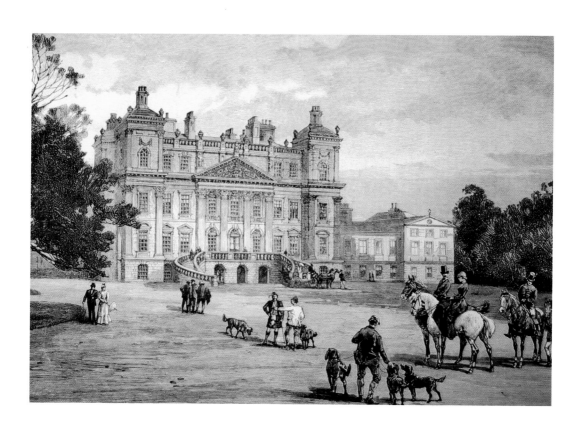

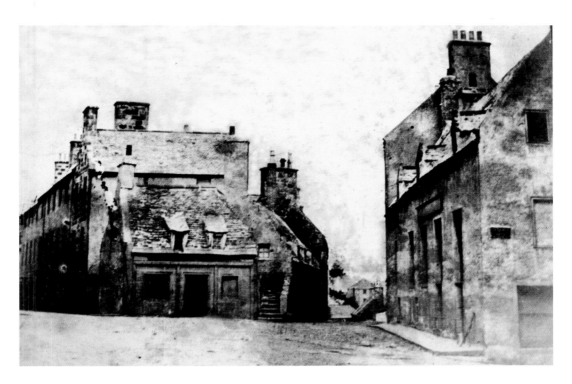

## Old Castlegate

Old Castlegate, unchanged, slanting down to the right, is probably the oldest street in town. In the foreground, the open space at the Grey Stone, a menhir now somewhere under the tarmac, was where people met before traffic. John Wesley preached here. Dr Johnson, while visiting Banff, commented on the Scottish taste for forestairs, and there is one still visible. The shop facing us in the modern picture is Bodies', the photographers, whose historic pictures are our mainstay.

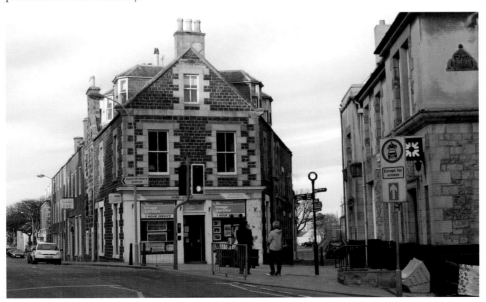

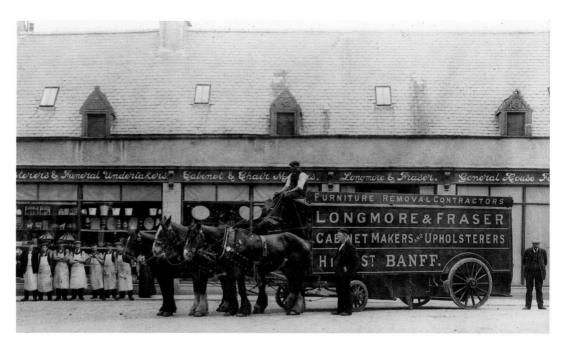

**Before the Royal Bank**

Probably Longmore & Fraser only put a new facing on the Bairds of Auchmedden's townhouse. The dormers with their stone heraldry were still there. The bank stuck them up on the side, and gave us some good twentieth-century heraldic stone carving as well. The Bairds have the grand, medieval-looking knight's tomb in the old kirkyard, which bears the same heraldry.

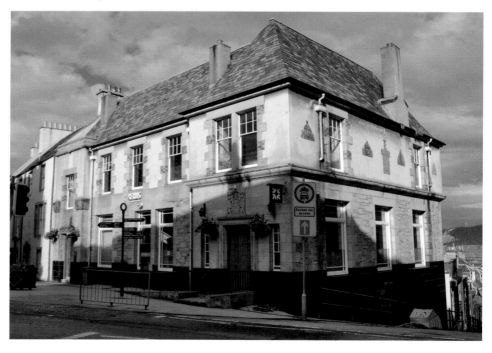

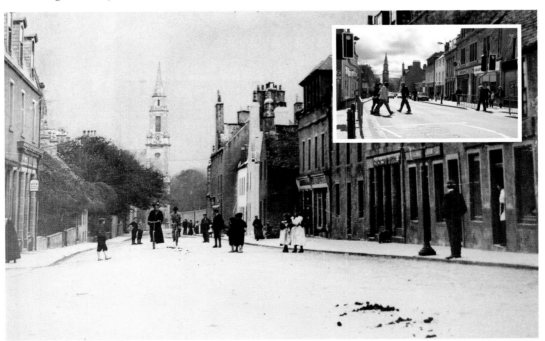

## Horses in the High Street

Yes, that is a Canadian Mountie in Banff. It honours the two Banffshire loons who built the Canadian Pacific Railway and named the Canadian town of Banff in honour of their home. The High Street had less traffic back then – which side are they cycling on? And we think that is horse manure in the foreground. Most of the buildings are the same if you look up, but the shopfronts and the pedestrian crossing, let alone the traffic, give the game away.

7

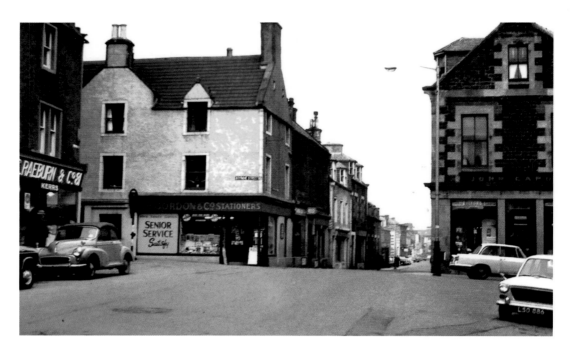

## A Phobia of Bottlenecks

In the 1960s there was a phobia of bottlenecks, so decent Georgian shops and houses were demolished to widen the High Street. We have gained a windy vista and some samples of '60s style. There is an amazing old home movie of the demolitions: the whole block comes down in a cloud of dust, and out of the dust emerges a moving car. They hadn't closed the road – no nonsense about health and safety then! There has been a paper shop on that corner for years. People remember it as Joss & Murray's – 'Joss' or 'Joass' is an old Banff name.

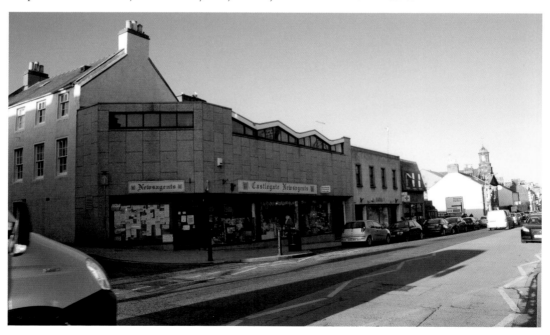

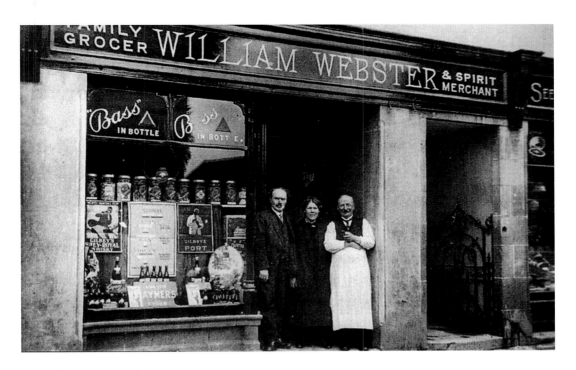

## Victorian Shopfronts

Sometimes the building survives, but tastes in shopfronts have changed. Here we have two views of the same building. Banff has some good late-Victorian shopfronts still, though we don't have any grocers left. Admire the gleaming plate glass, the excellent lettering, and the excellently structured, if rather alcoholic, window display. The sad thing is that somebody took trouble replacing it with the vertical crazy paving in reconstituted stone.

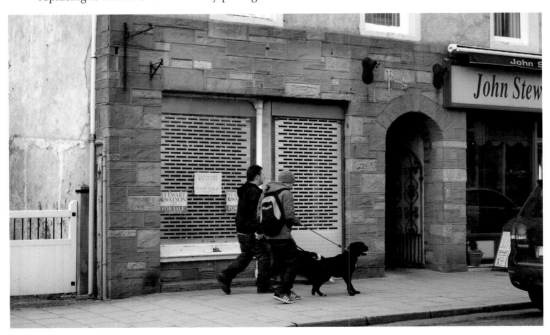

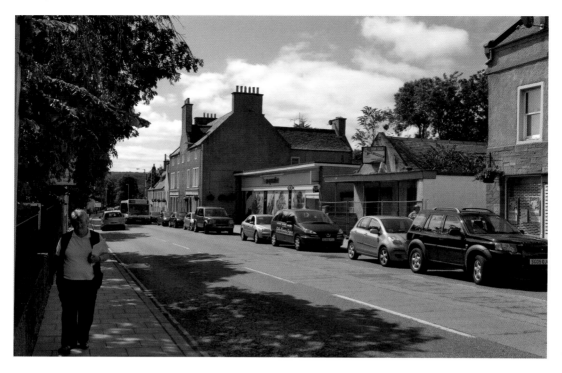

## Before the Co-op

The Banff Preservation Society was set up because of this demolition. The Co-op is a worthy institution, and its local store is handy. But to build it they knocked down some really historic work. A go-ahead town councillor summed it all up in the immortal words 'Ding 'em a' doon!' Old Banffers may recall when the long-derelict shack on this side of the Co-op was a greengrocer's. There are now plans to tidy it up and make it a covered market.

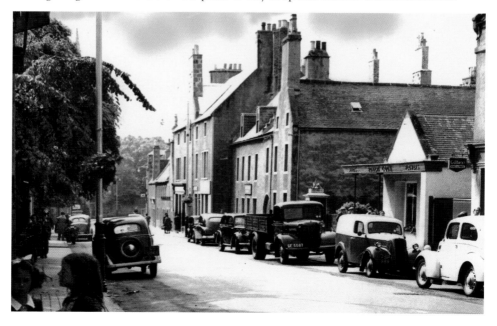

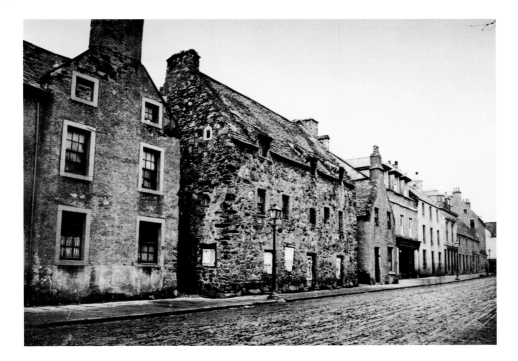

## Mary Duff's House

Many people can see the desperate gentility of Georgian houses down on their luck, but it might take a sharper eye to see the wonder of this one. These random little windows all over the place show that this was built a century before. Utterly scruffy and unloved, this is a genuine Scottish tower house. As it happens, it was Mary Duff's house, the home of the little girl who was Lord Byron's first love. Here Banff lost something special, and in its place there stands the Co-op.

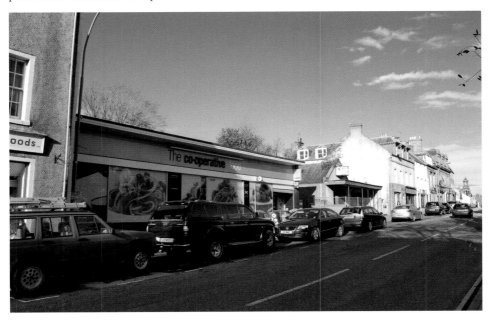

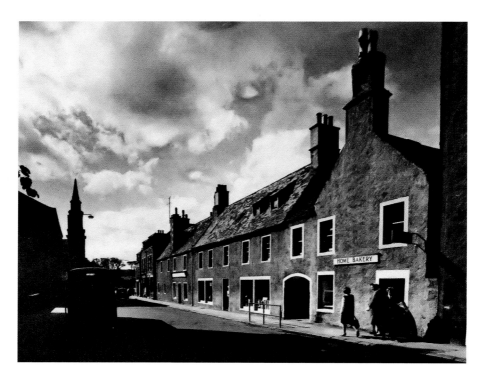

### Vernacular Restored on the High Street

These are small-scale, eighteenth-century vernacular buildings, restored by a local builder, A. D. Walker, with a commendably light touch. The shop windows, which were later insertions, have gone. The cat-slide dormer windows were rare survivors – most of Banff's dormers are Victorian – and were retained. There are some fine carved inscriptions just up Wright's Close, the arched pend.

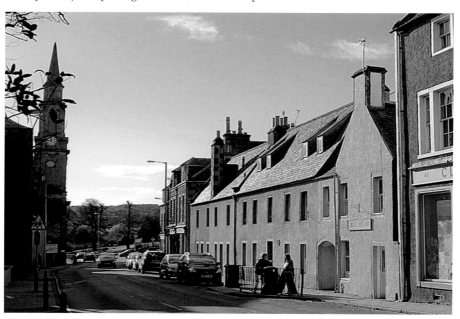

**From Georgian to Edwardian**
This big Georgian block, which was
built as a bank, was replaced by a fine,
elaborate Edwardian shop with housing
above, even bigger. For a time it was
a small supermarket. The out-of-place
modern signage was jumped on by the
planners and was removed while this
book was in production.

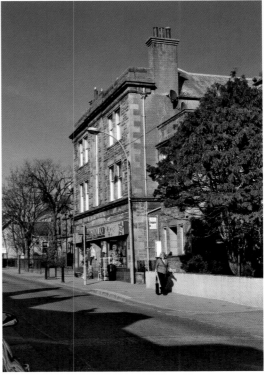

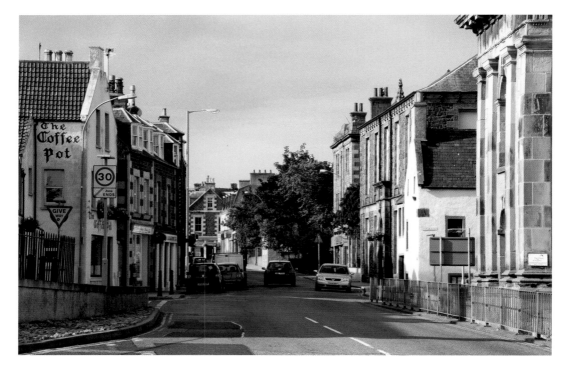

### Trees on the High Street

How much the High Street benefits from the trees in front of St Andrew's and the County Hotel. They are a continuing part of our townscape. Neither the trees nor the buildings show great changes in this picture, but the traffic, and the signage that goes with it, certainly has increased. The older photograph is early twentieth century, as we can tell from the library on the right, which was new in 1902.

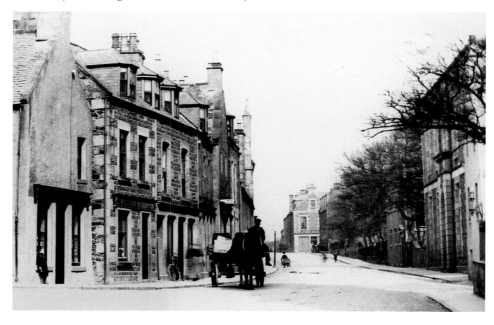

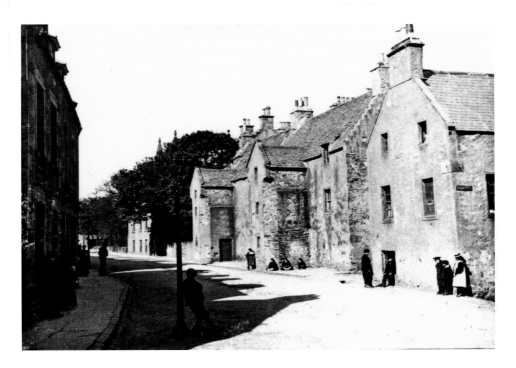

## The Turrets

The library and museum are rather bleak and functional Edwardian buildings, with some nice details inside. It is only when you see a picture of the buildings they replaced – the Turrets – that you realise what we have lost. The Turrets, probably seventeenth century, were rather shabby in their declining years, but these fine stair turrets should have been kept. The house nearer us was more fortunate, and has been taken care of. The sundial on the corner is still there. In the old picture it seems to have been photographed on a sunny enough day to tell the time by it.

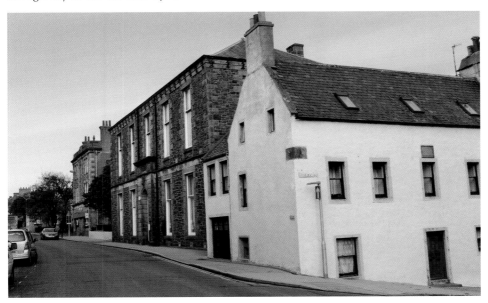

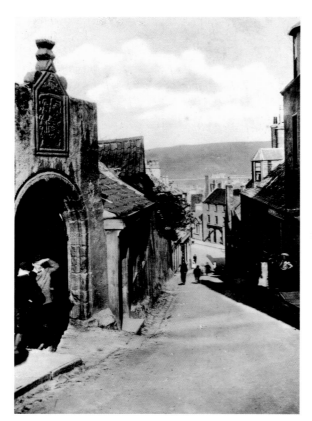

### The Strait Path

The Strait Path is an iconic Banff view. At one time it was the main road through the town from east to west. Shona MacLean has a memorable description of the presbytery arriving at a gallop down Strait Path in her novel *The Redemption of Alexander Seaton*. The arched entry with the coat of arms above belonged to the Baird of Auchmedden's townhouse. Later it was the home of the town's fire engine. The coat of arms is now higher up on the Royal Bank next door.

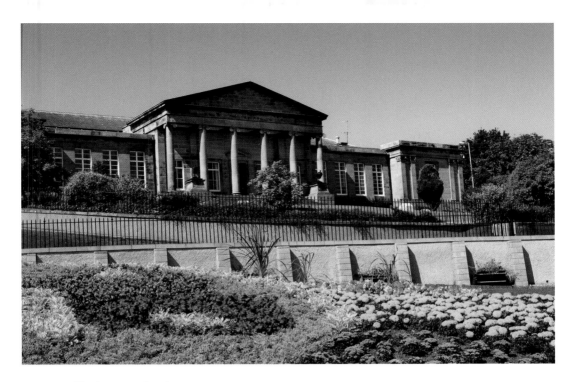

## Banff Primary School

This was Banff Academy, founded as Wilson's Institution in 1828. The central block was the original museum, where Thomas Edward, the self-taught Banff naturalist, was curator on a pittance. The building is now part of the primary school, which climbs the hill behind it. Internally it is as much a grand a statement of how we rightly value education as was this fine neoclassical pile. Probably the men with baskets are in the same line as the fine display of municipal bedding plants in the modern picture.

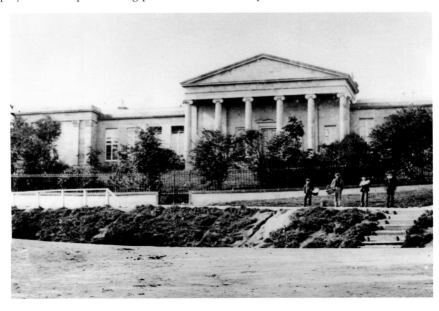

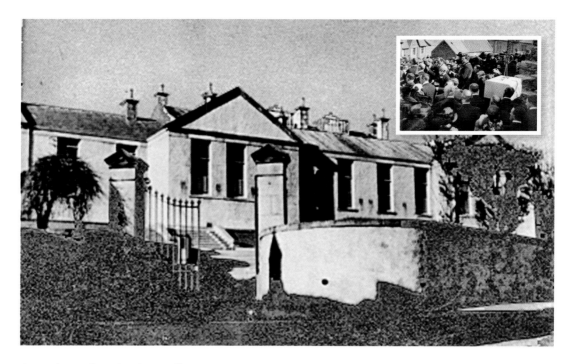

## Secondary Education in Banff

As we consider education, here is the senior secondary wing (the 'Higher Grade') of the old Banff Academy, with an inset showing the laying of its foundation stone in 1910. This was on Walker Avenue (then called 'the heads o' the yards') and it was demolished only recently. The modern picture is of the present Banff Academy, high on the outskirts of the town, with many playing fields and spectacular views.

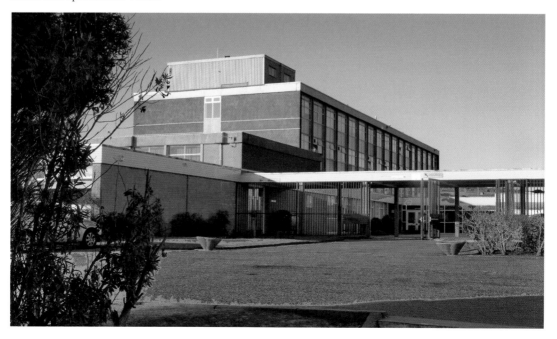

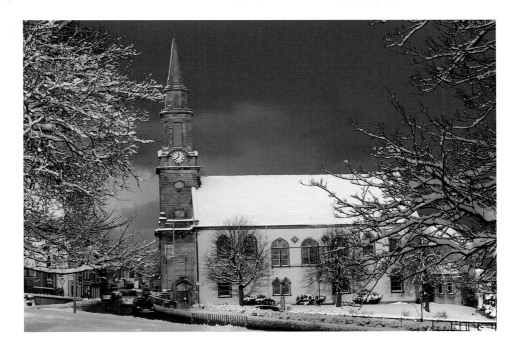

## Banff Parish Church

The parish church replaced the one in St Mary's kirkyard in 1778, although the steeple wasn't added till 1849. From this angle little has changed, though the side doors have and we might regret the loss of the fine iron railings. The trees beside the church have come on. Even in the nineteenth century, the roadway was close to the tower and rather high up relative to it, though there weren't thundering lorries then.

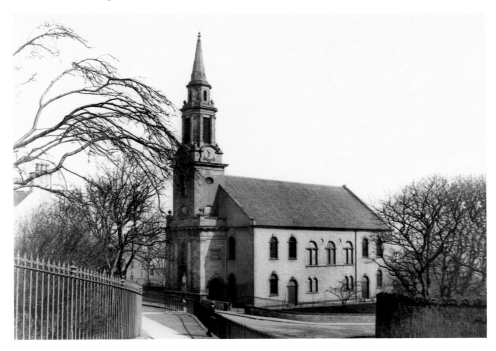

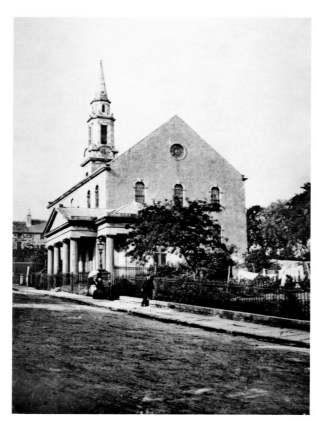

## The Collie Lodge and Parish Church

Seen from the east, there is a major change. In 1925 the Misses Martin built the chancel and apse, and went on to pay for the fine suite of halls to the north of the church. In the earlier picture, the Collie Lodge, in front of the church, was where you explained your business before you went up to Duff House. It is now the Tourist Information Office.

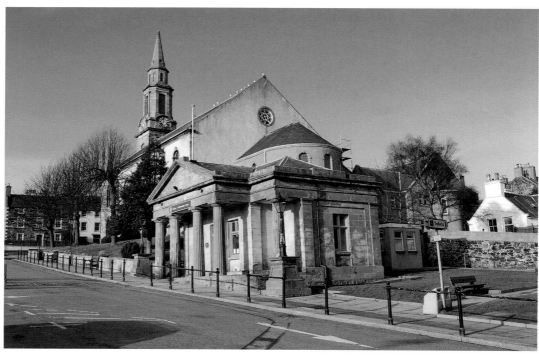

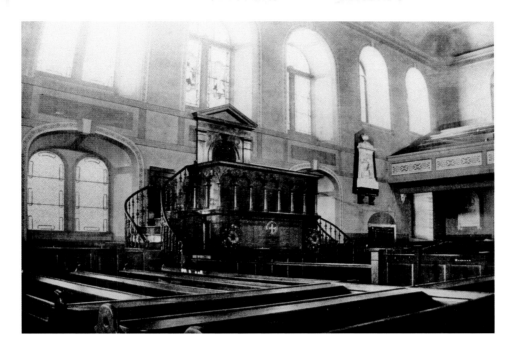

### The Parish Church – Interior View

In the church there were galleries on three sides around the magnificent pulpit high on the south wall. The galleries have gone, the Lord's Table has the place of honour in the east, there are choir stalls and the sermons are shorter. In all this, the Church of Scotland has become more like the Church of England. The spacious chancel lends itself to concerts, and the congregation does not miss the galleries.

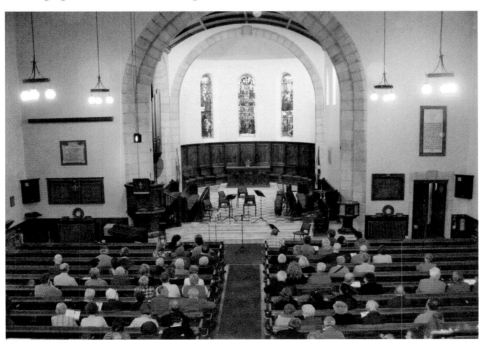

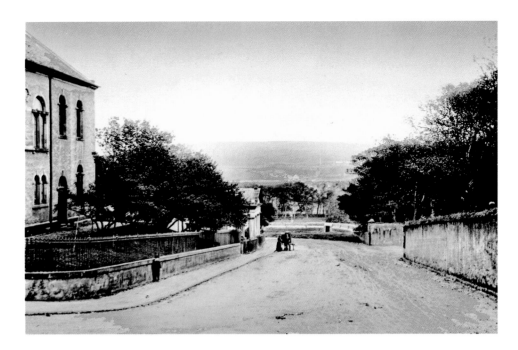

## Collie Road

When built, the new parish church was on the edge of the town. The old picture shows the Collie Road, and on the right the wall curving round and the trees behind it were all in the grounds of Duff House. Now we have the bypass and St Mary's car park. Straight ahead is now a sheltered housing scheme, Airlie Gardens. But indeed, before Duff House took them over these were the gardens of the great mansion of Lord Airlie in the sixteenth and seventeenth centuries.

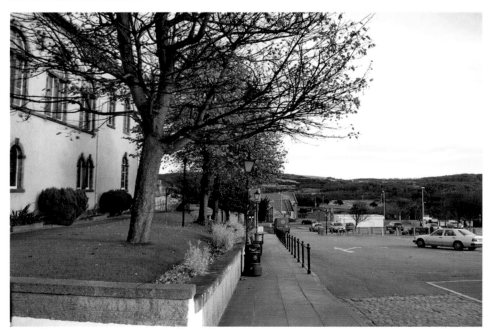

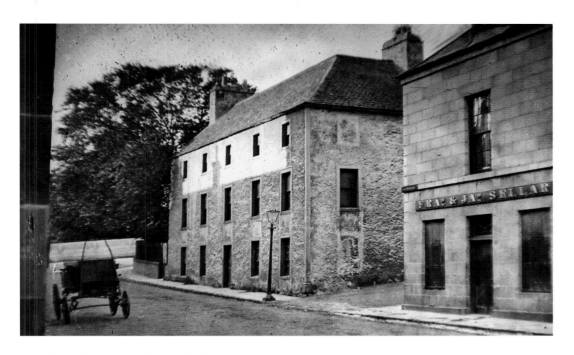

## Courthouse and County Hall

Ahead of us we can see the foot of Collie Road and the trees in Duff House grounds. The rather barrack-like Georgian building in the centre of the picture was the townhouse of Lady Gight, Lord Byron's great-grandmother, and he spent some of his childhood here. It has been replaced by the courthouse and county hall of 1870/71. Banffshire is no longer a county, but the courthouse still functions. They used to make public proclamations of new kings or election results from the gallery above the portico.

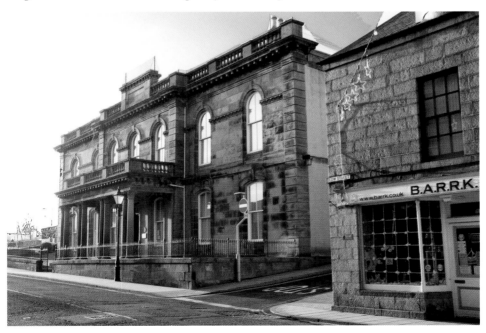

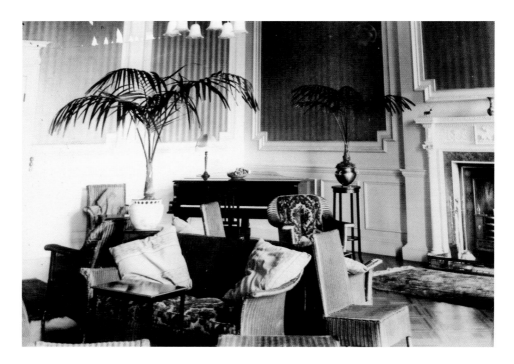

## The Fife Arms

The flanking wings of Duff House were never built, so there were not enough bedrooms for visitors. In the 1840s the Victorian earl built this fine block as overspill. In the twentieth century it became a rather grand hotel, the Fife Arms, with a very grand proprietrix. The old image shows an interior of this period. The central block is now flats. It does not take a feat of imagination to see horses and carriages clattering out of the archway to the yard behind.

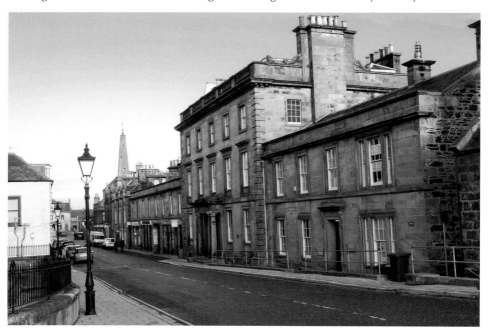

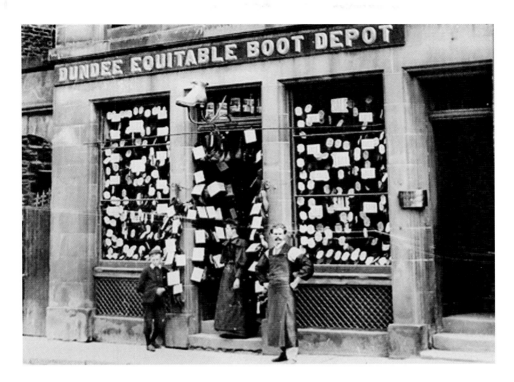

## Shops on Low Street

This is the same shop then and now, showing late Victorian, rather busy ideas of window dressing. Notice the carved boot hanging above the door. Every shop had a boy sent to deliver purchases, because it was not done to carry parcels. The shoe shop further along the street is still Dundee Equitable, only now it calls itself DE. As so often with modern frontages, you have to lift your eyes to see that the bookies are in rather a grand building.

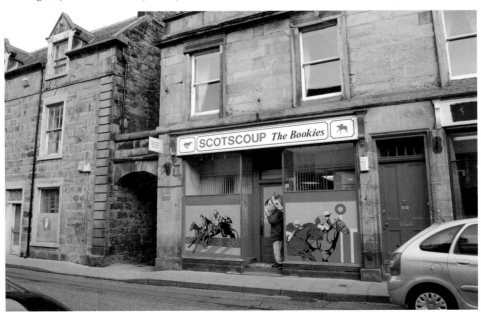

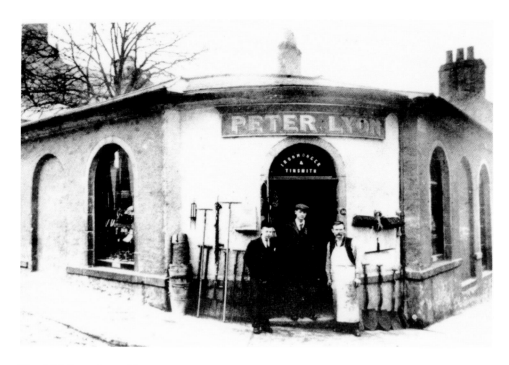

### The Old Peter Lyon Shop

The replacement building does make something of turning the corner, though purists might jib at the fake battlements. The old building was, we rather think, military in origin. Everyone who knew the old Peter Lyon shop has stories of how you could get anything there. Perhaps its natural heir is the Spotty Bag shop. Without making unkind comparisons, the staff of the modern office look more helpful than their predecessors did 100 years ago.

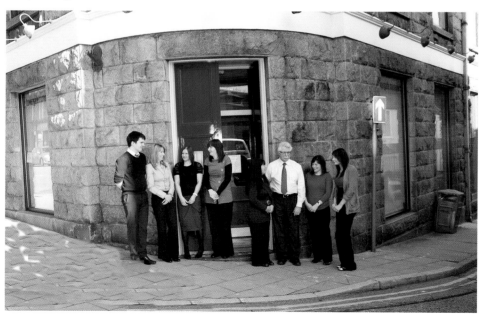

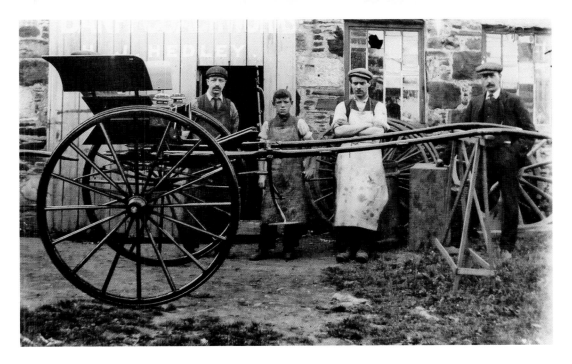

## Ready for the Road

Here are two transport photographs, more than a hundred years apart. First we have a team who have got that gig ready for the road, and second the staff of the County Garage in Banff. Our boiler suits look smarter than their aprons. Possibly a historian of headgear would see evidence that the intervening generation, whose members wore nothing on their heads, has passed. How you would have to wrap up to go out in a gig!

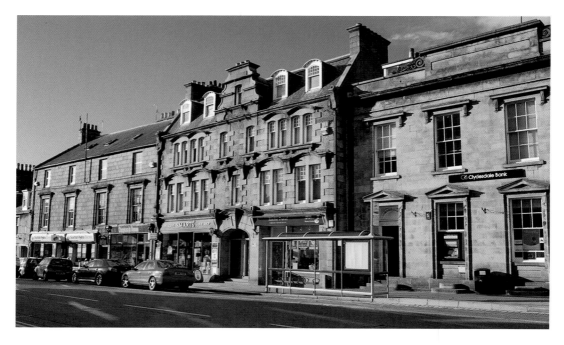

## Trades Hall

The nearer building, in the old photograph, was the Trades Hall. The Incorporated Trades of Banff were dissolved in the 1830s, but the hall kept the old name. It is likely Charles Dickens gave a reading here. Banff liked Venetian windows, and these upstairs are a good example. The County Museum Service now has the oval emblems of the Trades from the façade, but somebody in the interval has given them a coat of paint. The replacement building is magnificently florid Edwardian, demonstrating what can be done with granite once you have the tools to cut it.

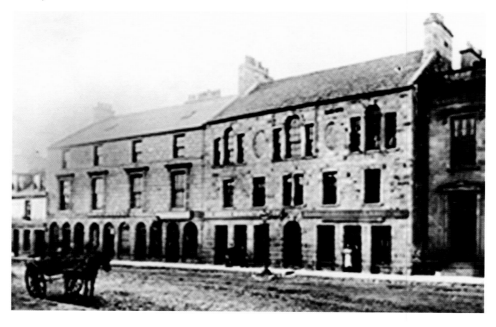

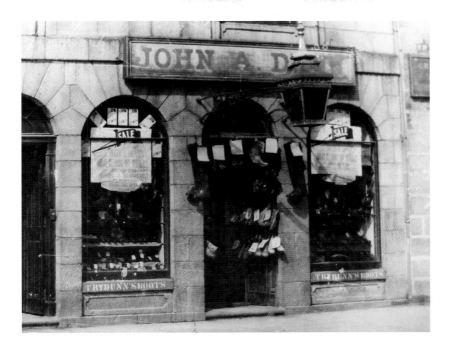

### 'Try Dunn's Boots'

Shop windows were the latest thing in the early nineteenth century, and Banff had a fine early row of round-headed ones on Low Street. Only the round-headed doorway is left. 'Try Dunn's Boots': the shoemakers had been one of the six Incorporated Trades, and Banff once had dozens of them, but to have a window display is something more. Chapter and Verse, who have replaced them, sell our books and are to be thoroughly recommended.

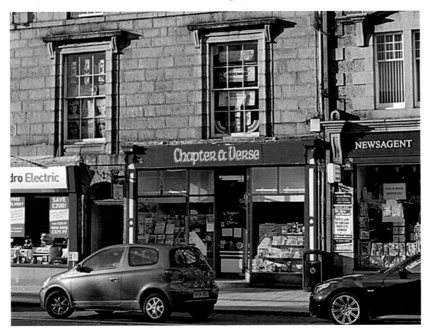

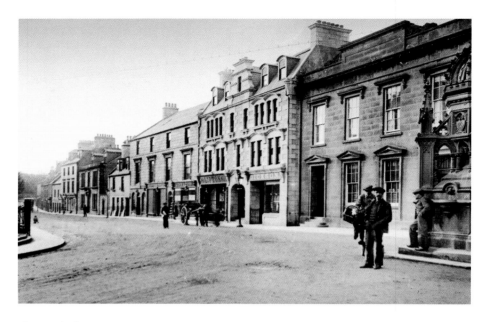

### Shop Windows on Low Street

There are still three of the old round-headed shop-windows in this early-twentieth-century picture. If you lift your eyes above the ground floors, very little has changed. Notice how Georgian Banff, wanting to make a splash, was built in dressed sandstone, while Edwardian Banff was built in granite. There are distinct potholes, and the street looks very muddy – think of crossing that in a long skirt!

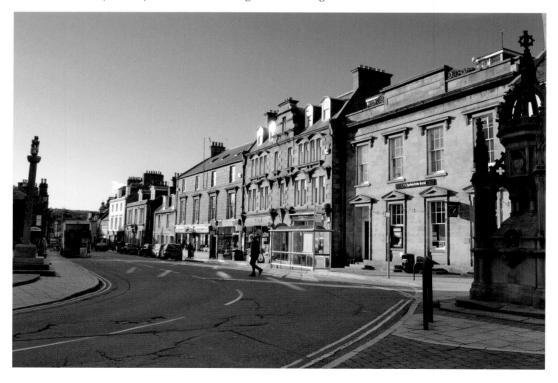

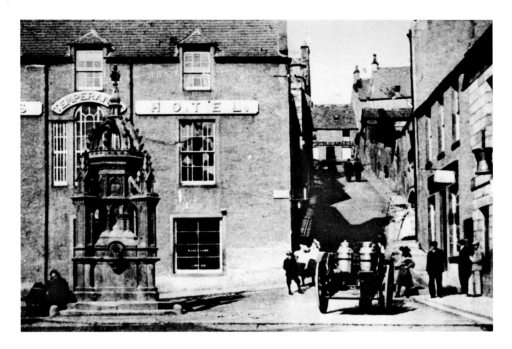

### The Tolbooth

The building on the corner of Low Street and Strait Path was the old Tolbooth, where the traders paid their tolls, where the Town Council met, and where the jail was. A Temperance Hotel might be evidence of high principle, but it is more likely to mean they had lost their licence and were making the best of a bad job. That is a very interesting pattern of astragals in the Venetian window. Though the ground-floor has been tidied up, the upstairs in this fine Regency hotel visibly begs for tender loving care.

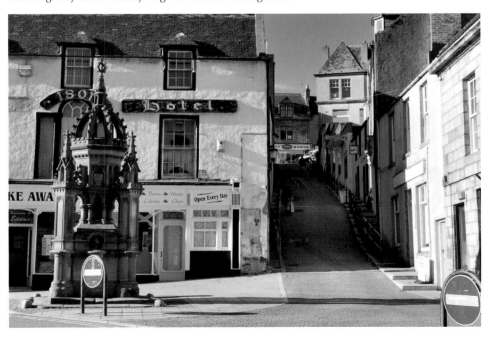

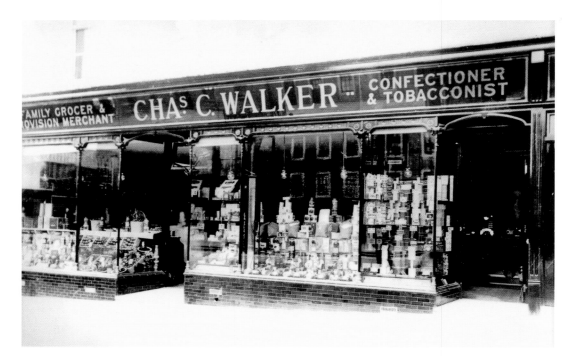

### Naughty but Nice

The Edwardians ripped out the whole ground-floor frontage of a Regency mansion, and filled it with plate glass, with elegant cast-iron mouldings round the edge, and then they piled the windows high with groceries. The lettering above is a joy to behold. The twenty-first-century touch-up is greatly to the owner's credit, though there is no longer occasion to browse.

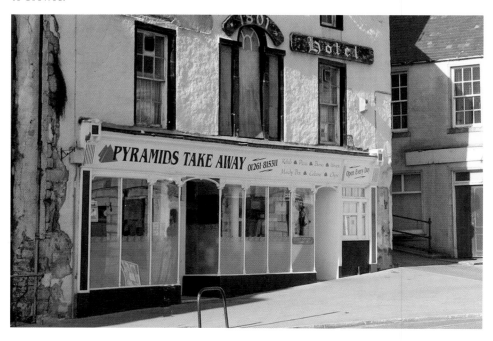

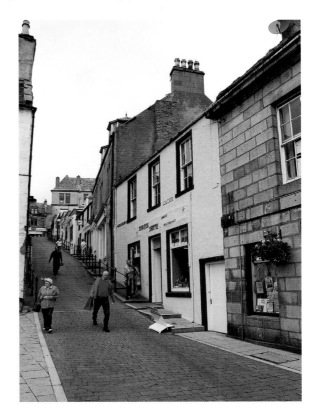

## Baker's Shop

In a modern baker's shop in Banff, you are almost certain to be served by women, but these are all men, and all in the appropriate long, white aprons. And there is the horse and cart for deliveries. They sell cocoa and chocolate, and next door, after all that sweet stuff, there is a dentist's, still remembered with horror. Strait Path, where little shops come and go quickly, seems to be looking up.

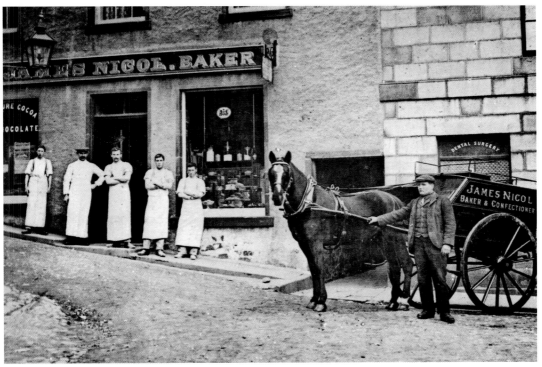

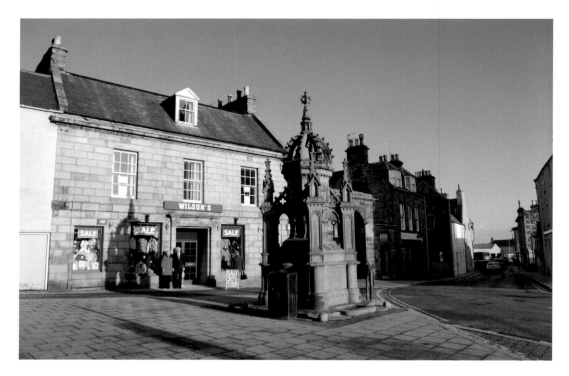

## Biggar Fountain

This is a picture of the Biggar Fountain, just installed in 1878. The road was up because water had to be piped to the fountain. Walter Biggar founded the herring trade with the Baltic, which brought great wealth to this coast, but died during the Russian Revolution in 1917. The man who carved it was John Rhind, a Banff loon who became a leading Scottish sculptor. The mansion behind, once Biggar's office, was already a clothes shop, as it still is.

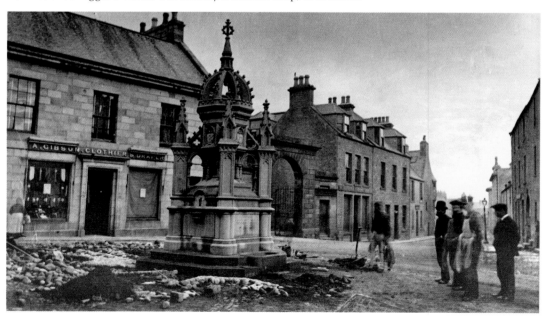

## Mercat Cross

The Mercat Cross marked where the market ('mercat' in Scots) took place. The Banff cross, with the crucifixion on one side and the Virgin and Child, the town's coat of arms, on the other, is early and rare. It was moved away as a traffic hazard in the late nineteenth century, and stood on top of the earl's doocot on the southern fringe of the town. It's back now, with some parts replaced (the originals are in storage).

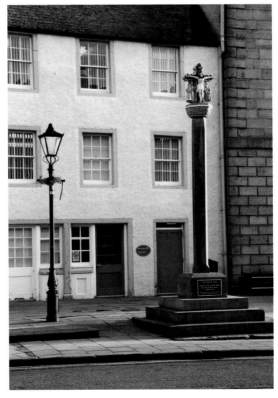

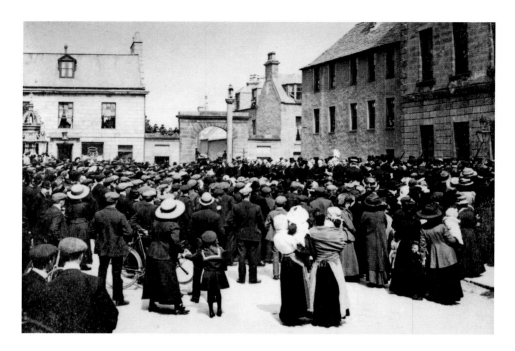

## The Plainstones

The Plainstones, in front of the townhouse, was the only paved part of old Banff. There was where crowd scenes happened. We think the early picture is of the proclamation of a king, perhaps George V in 1910. The modern one is of a wonderful piece of street theatre, which took a delighted crowd all round Banff following the fate of the freebooter James McPherson. In real life in 1700, after breaking his fiddle over his knee, he was hanged here, in front of the Plainstones.

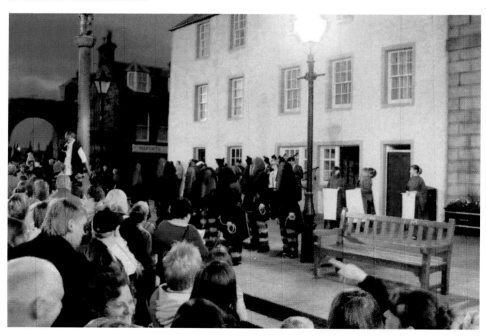

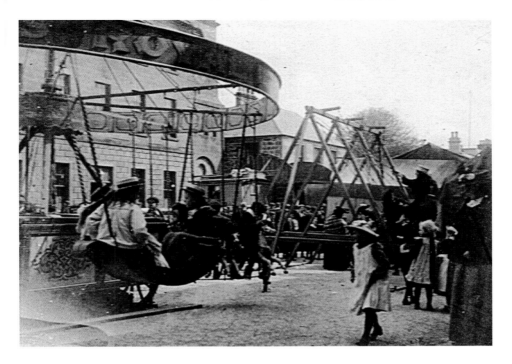

### St Brandon's Fair

It was not only proclamations, hangings and markets that happened at the Plainstones; here is all the fun of the fair. Nowadays this would be down beside the river. Our source says this was St Brandon's Fair, still going just before the First World War. Perhaps the choice was between the Mercat Cross and the carousel, and the Cross lost. From the dawn of public transport we have pictures of the first buses to Macduff leaving from the same spot.

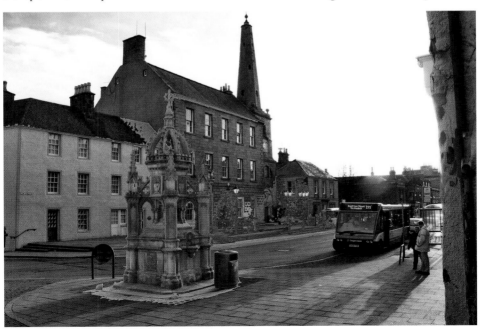

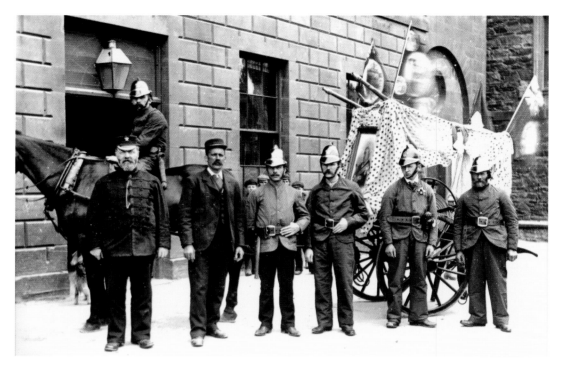

### Posed on the Plainstones

The Plainstones lend themselves to photograph opportunities. The old picture is of Banff Fire Brigade. They have decorated the cart for the Diamond Jubilee of Queen Victoria in 1897. It would be more than thirty years before they got a real (motorised) fire engine. In its day, the Banff Pipe Band played weekly on the Plainstones. Today's young cellists are happy evidence of classical music and sunny weather.

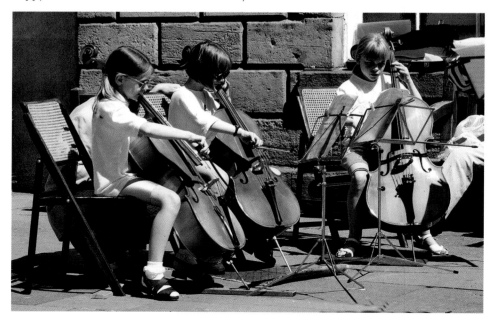

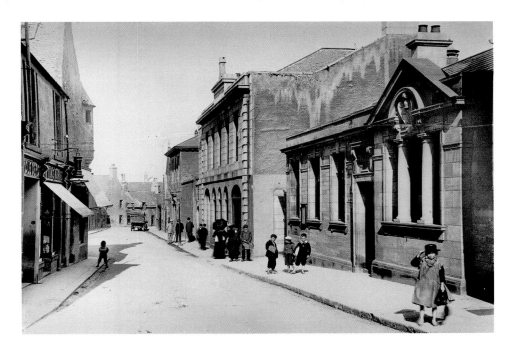

## Carmelite Street

Not even the oldest photograph will show any link on Carmelite Street with the medieval friars, though Victorians said older buildings on the right had interestingly arched cellars. The old post office on the right is a fine Beaux Arts Edwardian piece, and the far building beyond was once the police station. If you look hard you can see that where the parking is beside the kirkyard opposite Tesco there was a row of houses once.

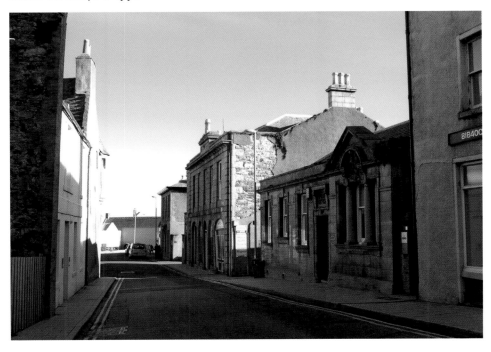

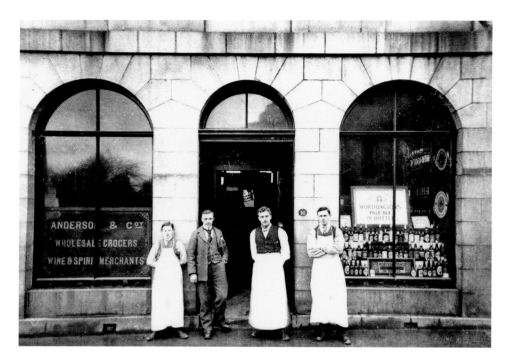

## Grocers' Shops

Whenever you look at old pictures of grocers' shops, their window displays tend to stress the wine and spirits side. Banff's grocers' shops have gone, replaced by the supermarkets, which also pile alcohol high. The Tesco building, which replaced a church and the Banff foundry, makes an attempt to fit in. This is to the credit of William Low's, the earlier chain, who were bought out. The planned new Tesco is somewhat less tactful.

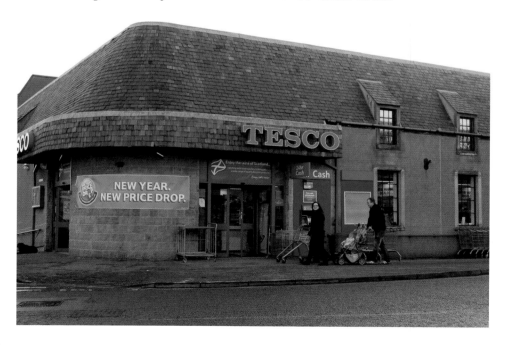

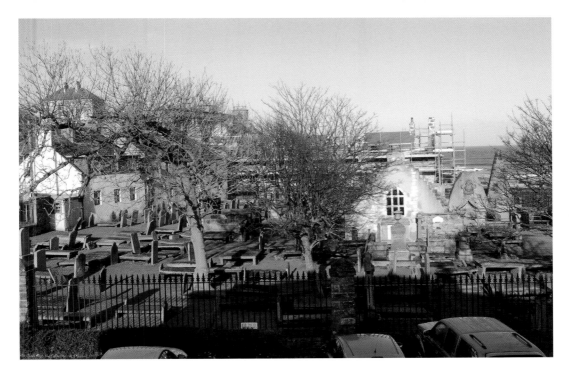

### St Mary's Kirkyard

St Mary's Kirkyard is a national treasure, and the less changed we can report it the better. In fact, a hundred years have taken their toll, and many of the stones are much less legible, but certainly most are still there. The Banff Aisle (Banff as in Lord Banff), all that is left of the old parish church, has been handsomely restored. What is that wire going across the old picture?

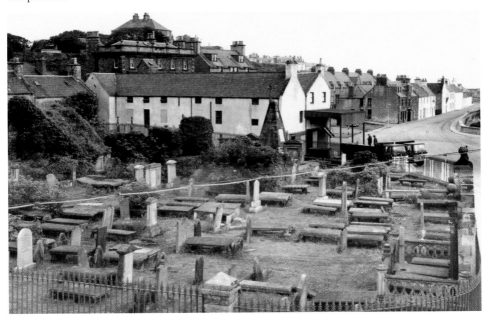

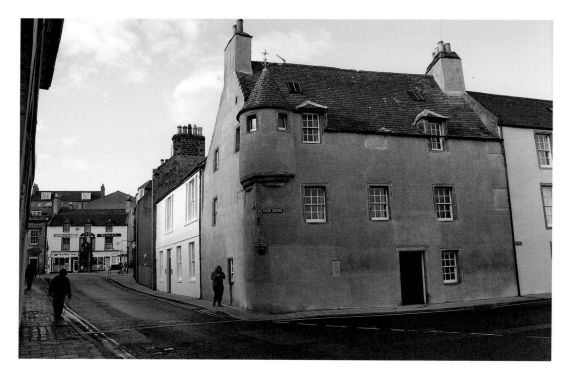

## 1 High Shore

1 High Shore is a rich merchant's tower house from 1675. You would have had to go inside it to see what a mess it was in before the Banff Preservation Society restored it. There was a shop on the ground floor, and multiple occupancies. The society won international awards for this restoration, and the house is now beautiful and well-loved.

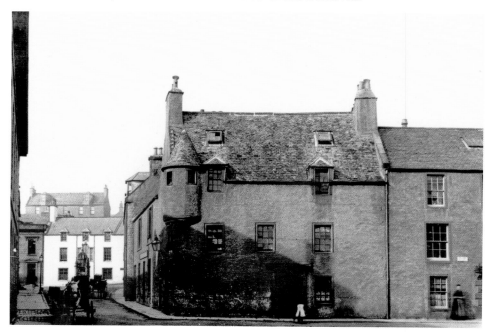

### 3 High Shore

This is 3 High Shore, The Silversmith's House, another of the society's restorations. This is lovely regular early Georgian, a generation later than next door. Silversmiths did quite well in Banff; the town had its own mark for silver, so you can collect Banff silver. There is a good display in the local museum, including the earliest surviving silver teapot in Scotland, which was made here. Knowing the history of Banff, the tea was smuggled.

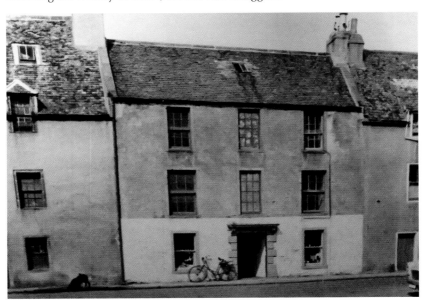

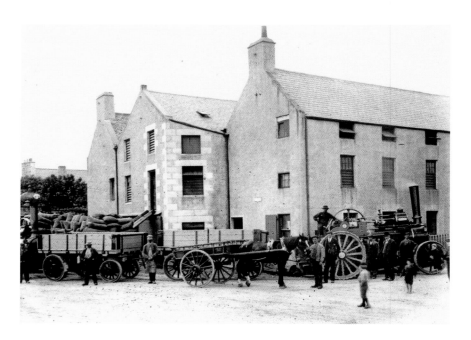

### Robertson's Granaries

This was Robertson's Granaries, with a display of their vehicles. That larger puffer must have drawn audiences all its life. With the central infill in the U-shaped plan removed, the fine old industrial building is now being renovated for housing. The restorers have been very respectful to old stone margins and window shapes.

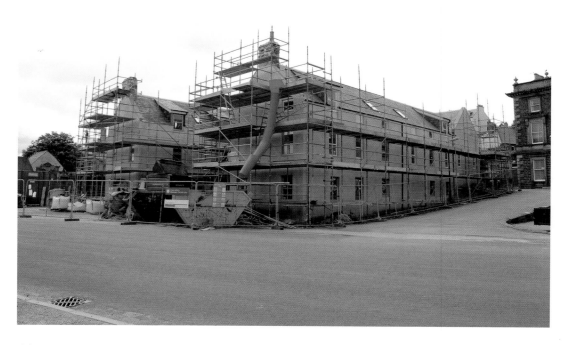

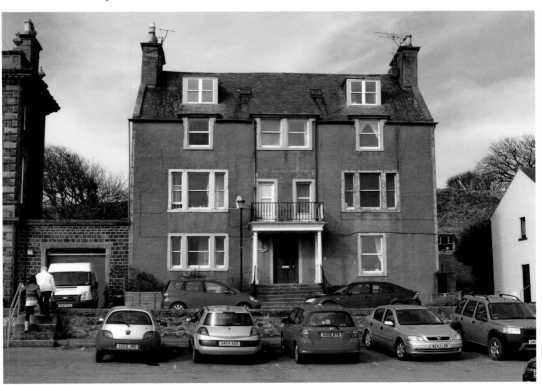

## Shore House

Shore House dates back to the 1730s, built by the smuggler provost, James Shand. After belonging to Byron's great-aunt, it became the Commercial Bank, and was converted into flats in the 1950s, when presumably the ivy went. With the usual late-twentieth-century priorities, the private garden in front has been replaced by a car park, and the railings and finials have gone from the fine porch.

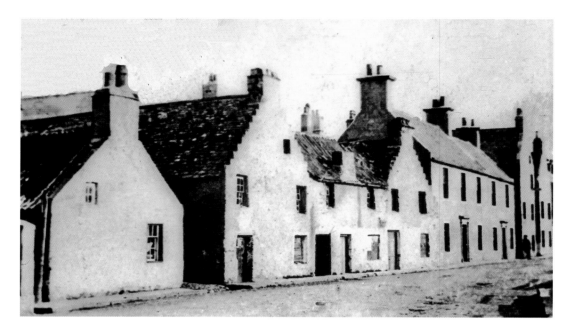

## Deveronside

This was the original harbour frontage of Banff. All along the North East Coast you find settlements with their gables to the sea, but Deveronside in Banff has only one. That is the Thomas Edward house, where the shoemaker who turned himself into a nationally known scientist lived. There is a plaque from the Linnean Society. The old photograph shows that there used to be several with gables to the sea. Plans have been drawn up to restore the sorrowful house with the dark-red sandstone margins. That sort of stone erodes very quickly by the seaside.

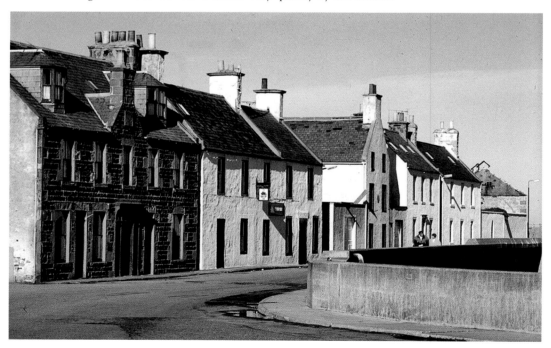

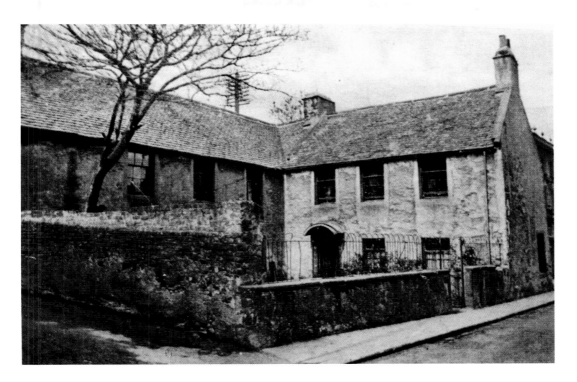

### The Old Manse

This was the old manse of Banff, just past the old kirkyard. Lord Byron, as a little boy, was a cousin of the minister, Abercromby Gordon, and 'stole' pears from the historic pear tree in the back garden. Banff was once famous for its pears. The ministers moved, first to the castle, then to genteel Sandyhill Road. Observe the Victorian magnificence of the police station behind, which was formerly a bank. The cells are as secure as a bank vault, which, after all, they were.

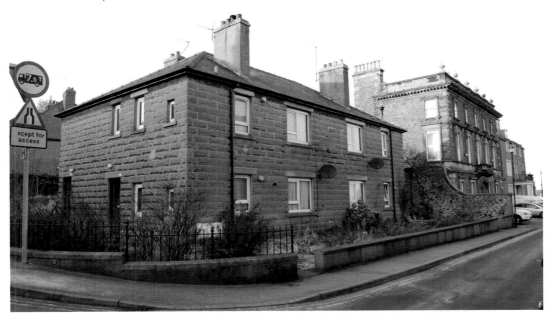

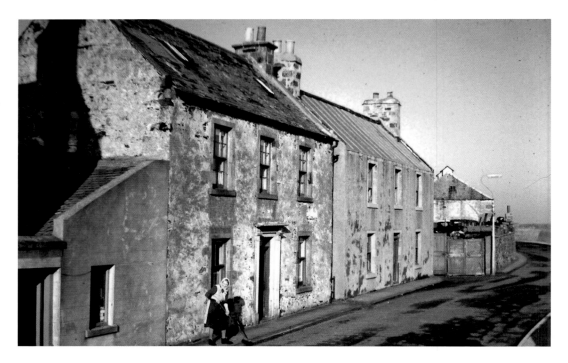

### Before and After on Deveronside

Here is a before-and-after that shows, once again, the work of the Banff Preservation Society. These houses really do look down-at-heel. What is that roofing material in the further one? The society bought No. 12 for a song, found grants and restored it. This was the society's first restoration in 1965. It is sobering to think that you can still see seedy Georgian houses in Banff, alas beyond the pocket of the society.

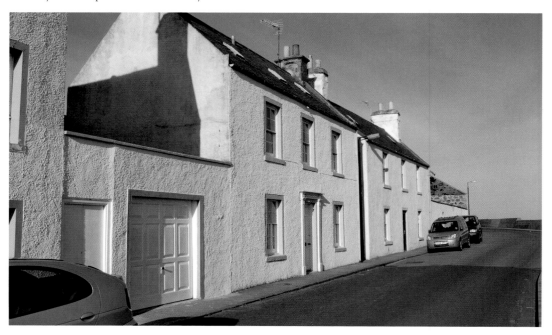

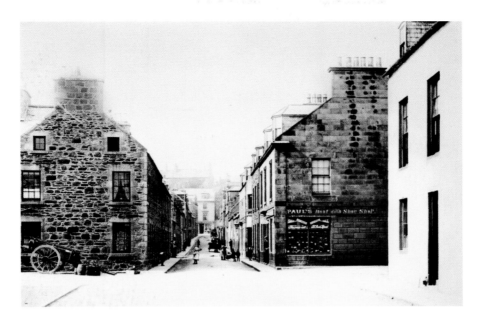

## Bridge Street

Bridge Street used to be the main entrance to the town. If you are interested in Georgian decay, then you can find it here. The block on the right at the No Entry sign is finely detailed and sadly needs attention. The *Press and Journal*, who only rented their offices there, have now gone, or we might have blamed them. Along the street there are some very attractive surviving details of Victorian shopfronts.

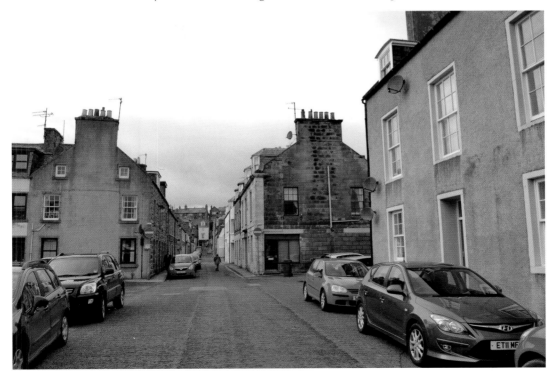

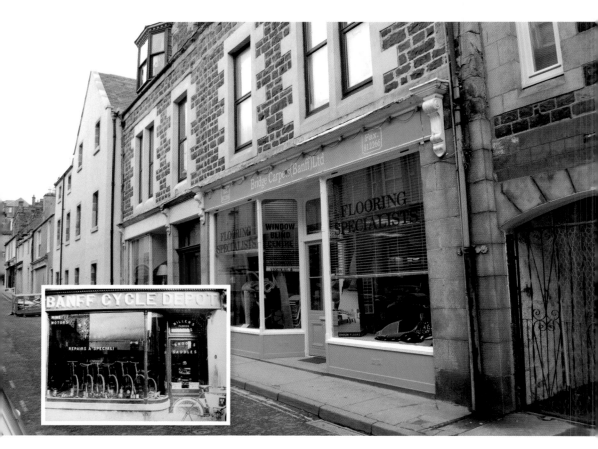

**Shops on Bridge Street**
We think that the fine curve of plate glass there in the old shop is the same window still in place.
These are not very old-fashioned bicycles, so it is not a very old photograph, probably from the
1930s. As you look down the street there is some new housing, decently proportioned, trying to
fit in. The sad story is that its decent old Georgian predecessor, after standing unloved for years,
just fell down, within very recent memory.

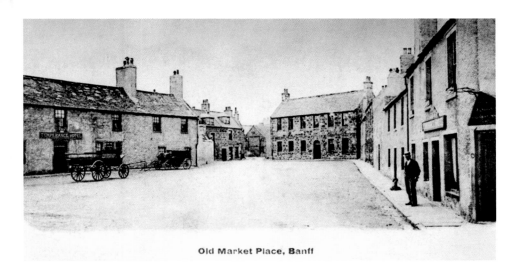

Old Market Place, Banff

### Old Market Place

The original market was on Low Street before they moved it here. After the Great Spate of 1829, when the Deveron flooded all this end of Banff, they moved it back to behind the Market Arch at the end of Low Street. Those who would have shopped at the market now shop, probably as regularly, at Spotty Bag just off the picture on the right.

The district around the old market place used to be very densely populated. Where Stewart Cheyne's own parking is, at the left-hand corner of the Old Market Place, the 1832 map shows two rows of houses end-on to the road, with only the narrowest of passages between them and their neighbours on either side. Look at the old photograph and think where would the bus get through there?

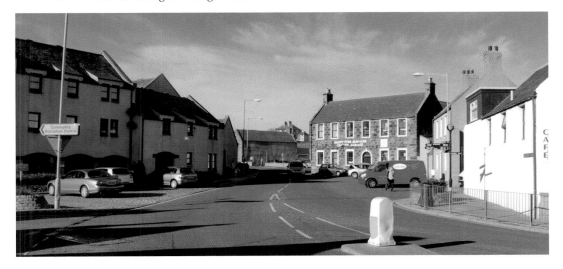

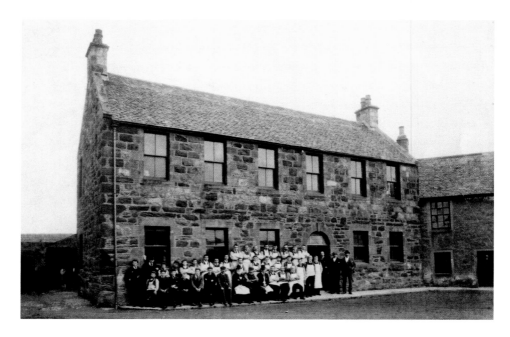

### The *Baffshire Journal* Offices

This was the old Grammar School of Banff. When Robert Burns visited the town he was entertained by the headmaster here. The original school had one storey and a belfry. When they heightened it with stones from the ruined parish church, they took off the belfry for safety, and rebuilt it on the Town Mealhouse or Girnal (behind us), later a smiddy. When the academy was built, the old school became the offices of the *Banffshire Journal,* and will soon have a plaque commemorating the first Aberdeen-Angus Herd Book of 1862. The picture is of the days when the *Banffshire Journal* was very well staffed.

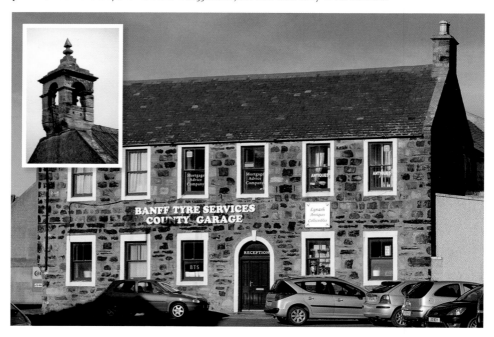

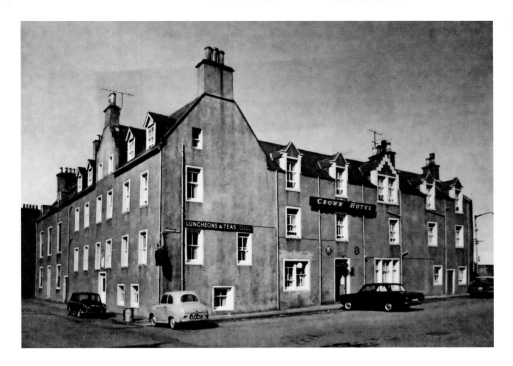

## The Crown Hotel

The Crown Hotel, as we can deduce from a page back, replaced a smaller inn. You need inns on marketplaces. It fell on hard times, but there were plans to make something of it when it was burnt down some decades ago, and replaced by modern housing. Crown Court satisfactorily fills that edge of Old Market Place in the way the old hotel did, though with some details which are obviously of their time.

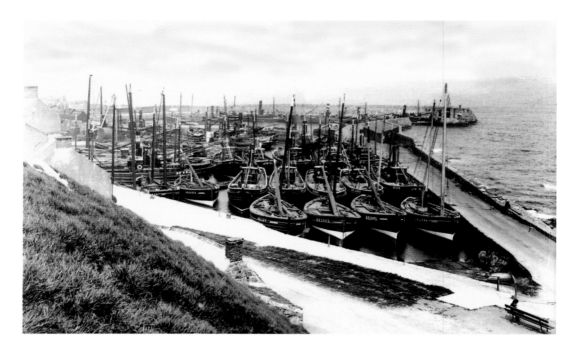

## Banff Harbour

The old harbour was full of fishing boats; the new one has installed pontoons for leisure craft. The nineteenth-century herring boom ended with the First World War, and from then on Banff had almost no fishing boats. Of course the Macduff boats are labelled BF, and between the wars the Banff harbour was sometimes, out of season, filled with Macduff boats. One of our editorial team, as a councillor in the '6os, fought off a proposal to turn the harbour into a car park.

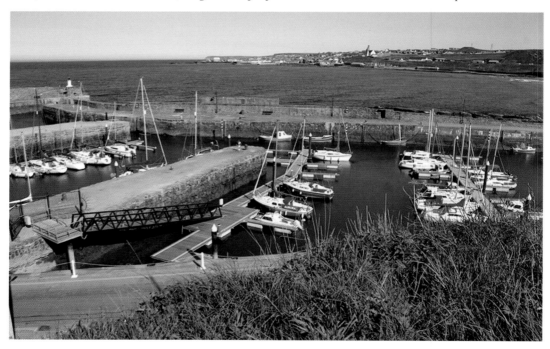

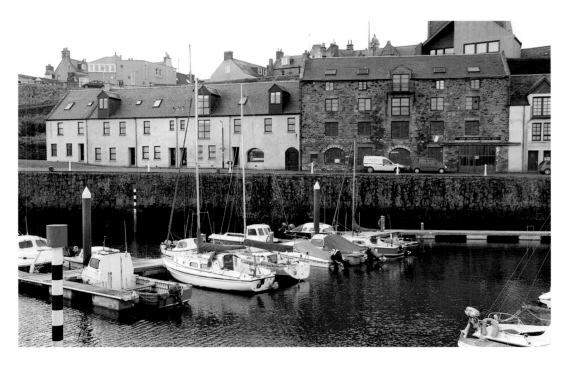

## Dockland

This was dockland, industrial Banff. Part of the chimney is still there; it had to do with tarring ropes. The mechanic's business is closing down, and its replacement, like almost everything else beside the harbour, is likely to be residential. The buildings have been reused rather than demolished. As in other old local harbours, the stones of the pier were set vertically.

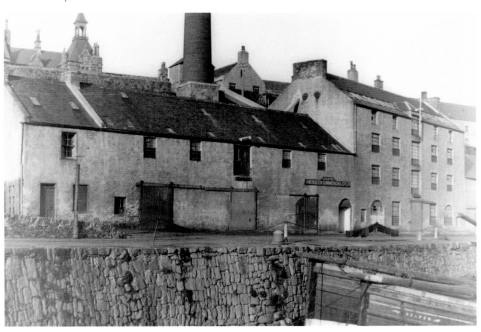

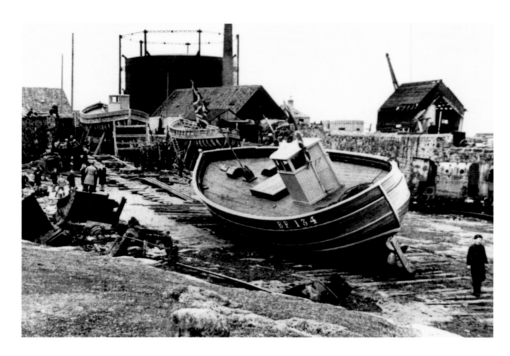

### From Working Harbour to Leisure Harbour

Was this an occasion? There seem to be a lot of people there at the slipway. There used to be a railway spur from the harbour station coming right out onto the pier. This was a working harbour, and not just for fishing, but for coastal trade. Harbours are very difficult to engineer successfully, and though Banff had the great names Telford and Smeaton, this one always silted up. Blame the Deveron. In the background you can see the town gasometer, long gone.

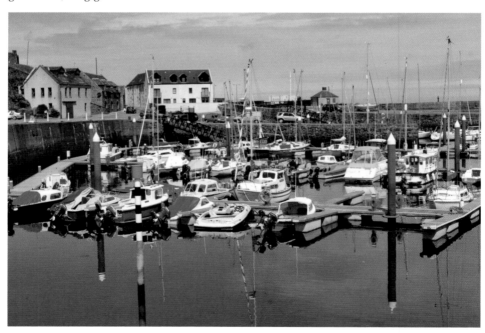

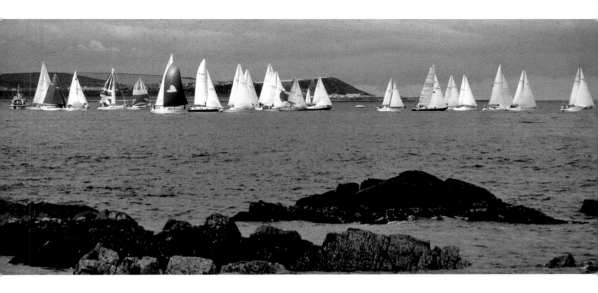

## Trading
These fine schooners were for trading between Banff, London and the Baltic. You might be able to pick out the railway track on the nearer pier; certainly you can see the barrels. Coopers (who make barrels) were one of the Incorporated Trades of Banff. The modern picture reminds us that there are fine boats still: this is the Banff–Stavanger Race in its early stages.

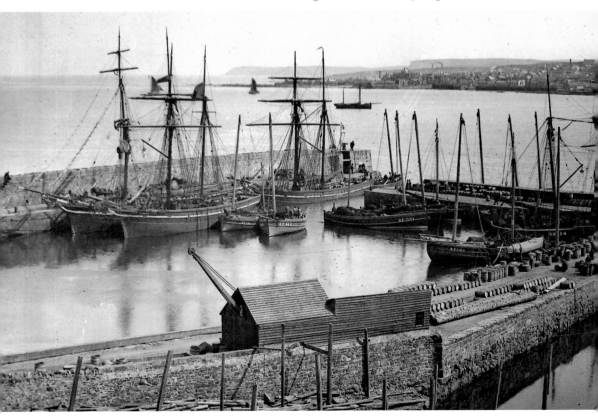

## Swimming

The barefoot laddies around the harbour are still there in fine weather. The modern picture is of the Banff to Macduff swimmers. The race was founded by the late James McPherson CBE, last Provost of Macduff, Lord Lieutenant of Banffshire, and a leading light of the Preservation and Heritage Society for years. What was more, he could swim the distance, and indeed held the record for some time.

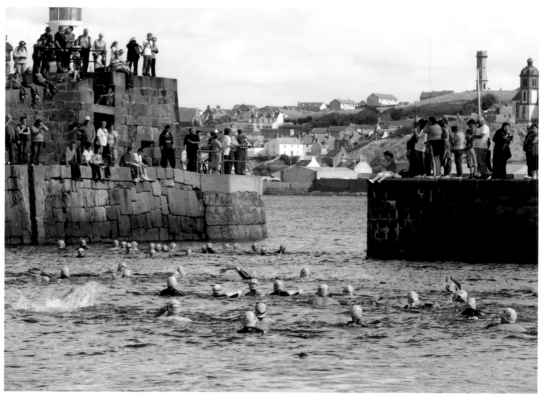

## Tea Clippers

We used to build tea clippers like the *Cutty Sark* at Banff. Look closely at the bottom right-hand corner of the old photograph, and you will see the tomb, shaped like a pyramid, of Admiral Gordon, in the old kirkyard. The *Ban Righ*, launched 1879, was built where the monumental mason's yard is now. In those days there was a big shingle bar across the bay, so, sheltered behind it, boats could be built, even big ones.

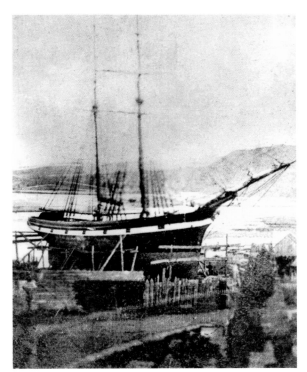

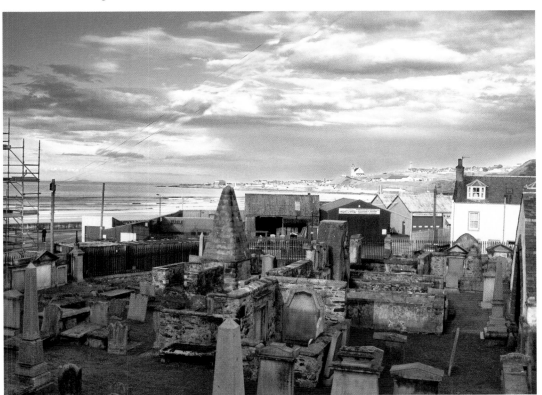

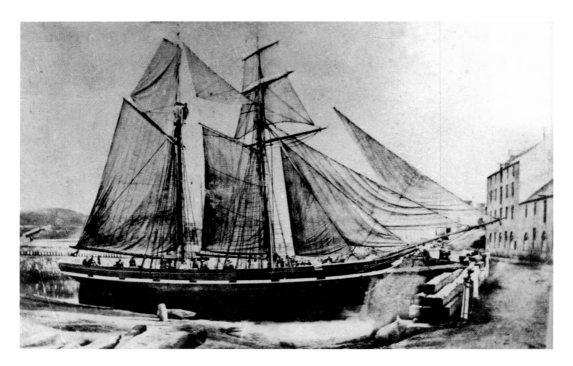

## Banff Harbour

The harbour was just big enough for this schooner, and it must have been a problem for traffic along the edge. Anyone who knows Banff harbour will be surprised it was deep enough. The modern picture, itself now part of history, shows the harbour drained for deepening. Dredging, in fact, is an endless task. The currents favour Macduff.

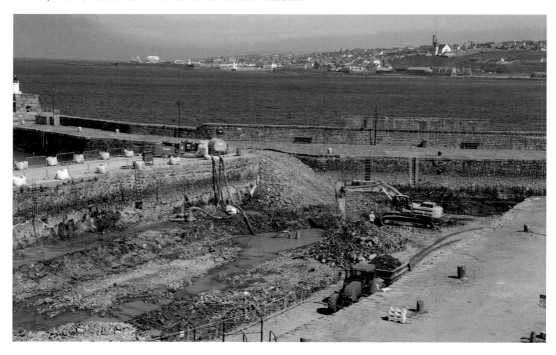

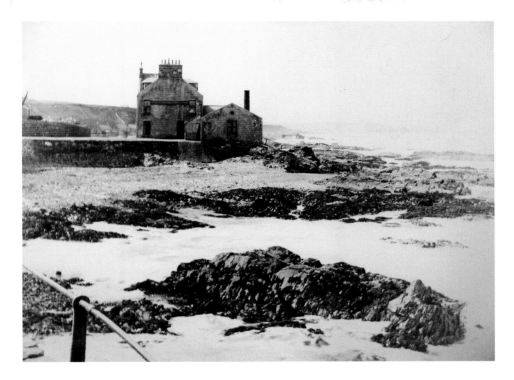

## Public Baths

The most thorough change between old and new Banff is beyond the harbour. Here there used to be a railway station, a gasworks, other industrial buildings, and old-fashioned public baths; all these have gone. The old photograph shows what were public baths – a commercial venture. Now there are car parks and, as this is on a sea-swept promontory, instead of flowerbeds there are patterned features of cobbles and rows of black-painted blocks of wood. Instead of the gasworks, we can now see Boyndie wind farm to the west.

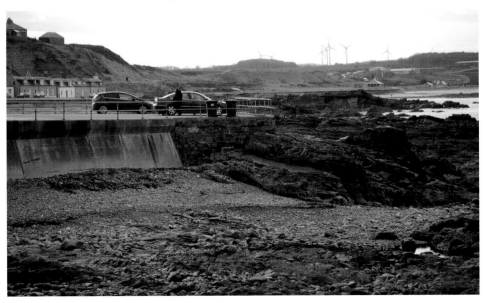

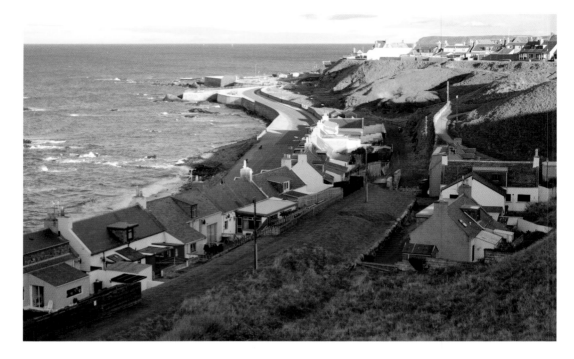

## Harbour Station and Scotstown

For a hundred years, Banff had two stations. One line approached the town along the coast behind Scotstown. The Harbour Station was the end of the line. There is a fine nostalgic film of the last passenger train in 1964. A later attempt to reopen the line as a toy railway from the town to the links failed after one season. One cannot imagine that the inhabitants of Scotstown grieved its passing.

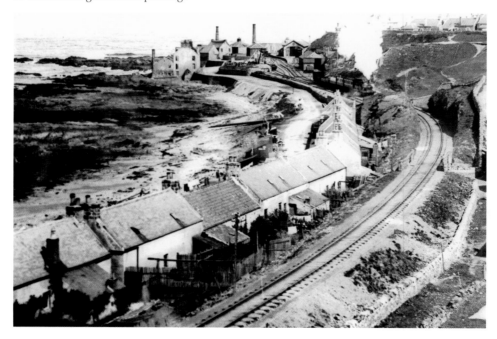

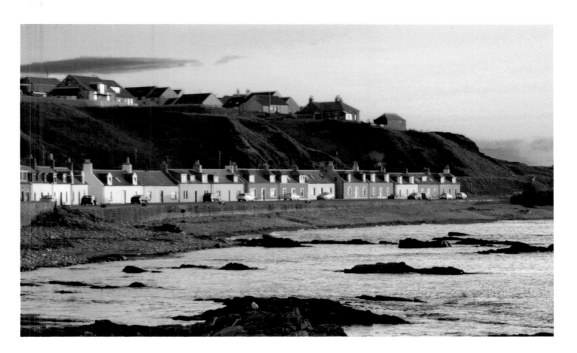

## Scotstown

In 1853 the Town Council of Banff bribed fishermen from Portknockie to settle in Banff by building them cottages in Scotstown, so that Banff could have its own fishing fleet. The old picture shows the nets drying in front. These are now very desirable properties, and the owners have recently fought the planning department, who said it should no longer be a Conservation Area. One test of a Conservation Area is whether you could plausibly film a costume drama there. You could re-erect nets, but could you disguise all the new doors and windows?

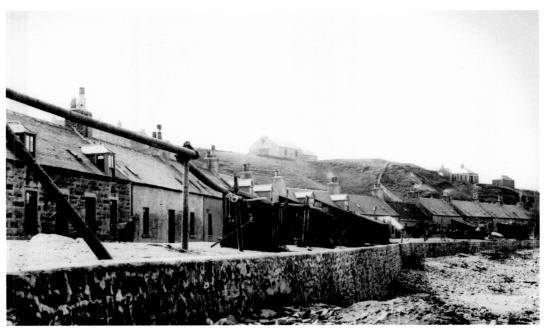

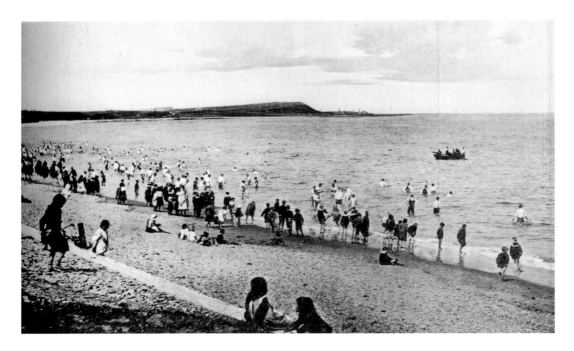

## The Banff Links

The Banff Links has been a popular place for sea-bathing for a long time. In both photographs quite a lot of people have kept most of their clothes on. The beach wins awards for being clean and tidy. Now that there are surfers in wetsuits (Banff has wonderful waves) there are people in the water through much more of the year.

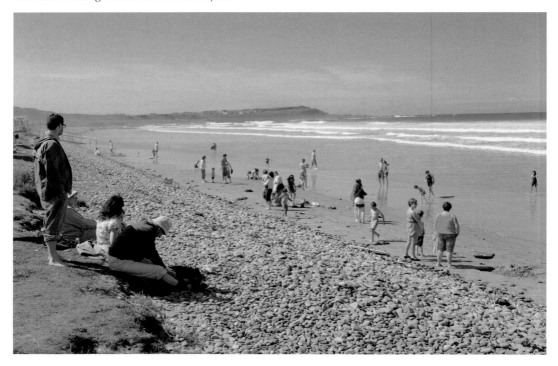

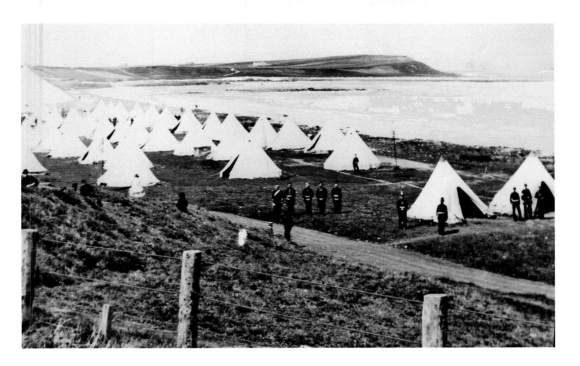

### Tents on the Links

Tents on the Links used to mean militia manoeuvres; nowadays it means the circus. From the 1870s the Links were the town's nine-hole golf course, but this was abandoned in the 1920s after a merger with the eighteen-hole Duff House Royal Golf Club. The fine equipment of the children's play area marks a change of period. In Victorian Britain children made their own amusements in the streets. Fifty years ago there were swings. Now everywhere there is colourful ingenious and safe public sculpture for climbing on.

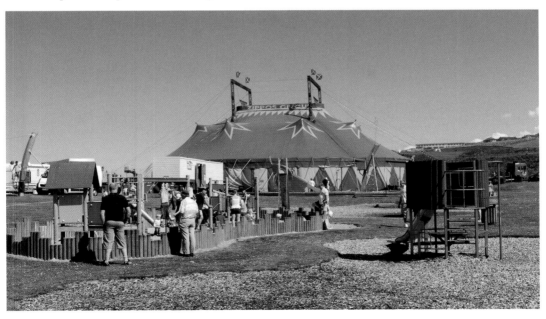

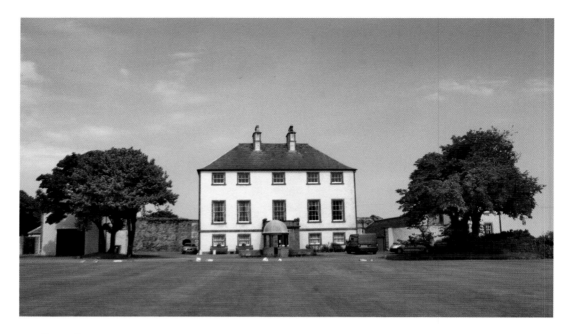

## Banff Castle

Banff Castle was built for the aristocracy, a home for a dowager Countess of Findlater. By the time of the earlier photograph it was a gentleman's house, and it remained in private hands until the Second World War. It is now in public use, with a new café in the wing on the left, and plans for a stage in the courtyard behind. The little temple-top to the well in front, as you can see, is twentieth century.

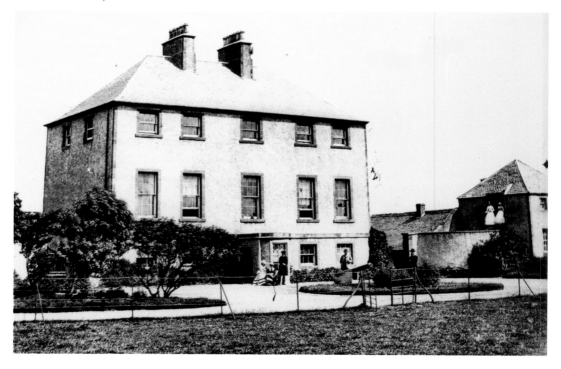

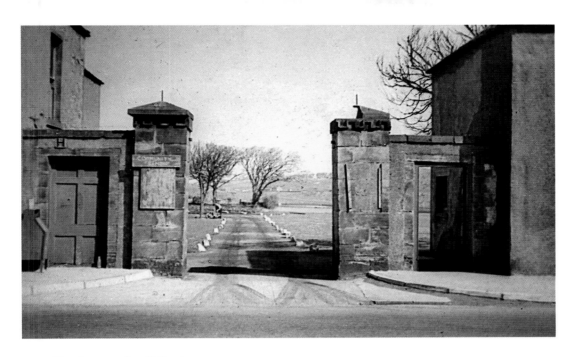

### The Gates to Banff Castle

The gates to the castle on Castle Street are not the original ones. These gates came from Duff House. They stood immediately facing the end of Banff Bridge. If you had business with Lord Fife, you carried straight on; if you were going into the town or beyond, you turned sharp right. The gate opening was widened in the 1960s. We hope you notice that the gates have been tidied up lately, with new authentic lanterns on top.

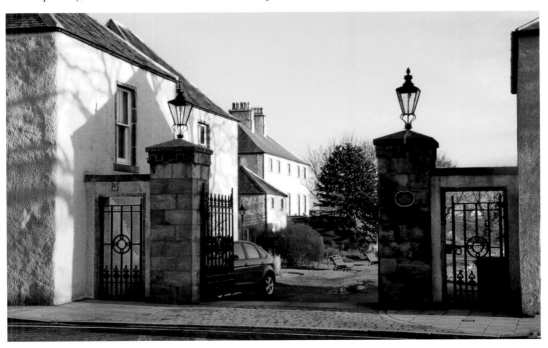

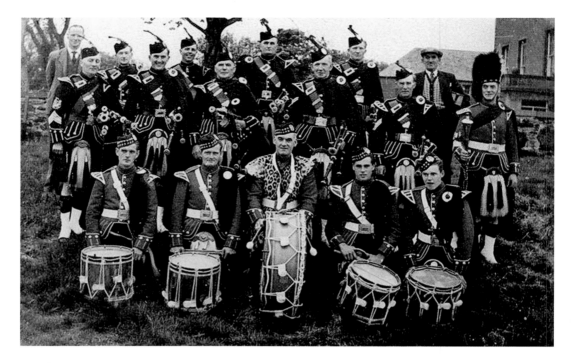

## Banff's Pipe Bands

Banff Pipe Band had a great pipe-master and a distinguished history, but fashions changed, and it disappeared. Very recently Banff Castle Pipe Band has emerged – too recently even to have their name on their drum. Every week if you go near the castle early in the evening you can hear pipe music.

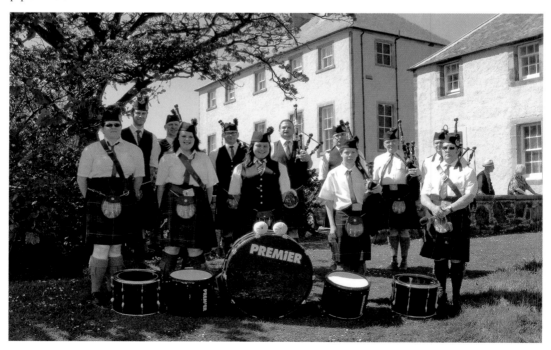

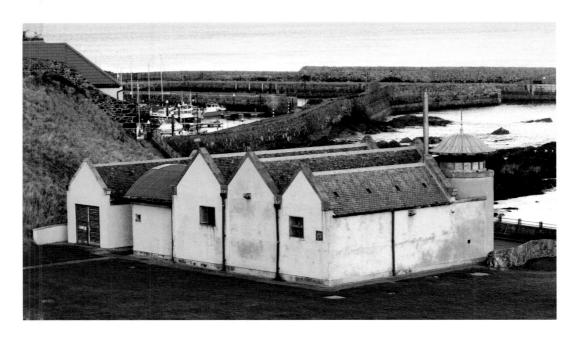

### Below the Ramparts

Below the ramparts of the castle, near the harbour, there used to be an open space where public events took place, and here is a huge marquee to prove it. The site is now partly occupied by a tastefully designed building in traditional style, whose use is rather hard to guess at. It is in fact a pumping and cleaning station, connected with sewage disposal. We cannot in a book of photographs show you the old smells of Banff, but we assure you the pumping station serves a good purpose.

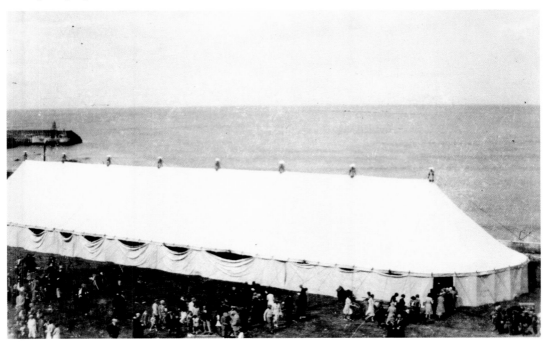

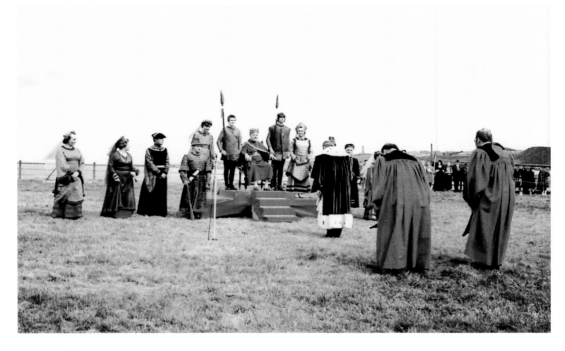

### Banff Pageant

Banff went to town with a wonderful pageant to celebrate the 600th anniversary of being re-granted its charter by King Robert II in 1372, with dozens of local actors in authentic costume, some on horseback. Lately a re-enactment society came to our medieval day at Banff Castle, and here is Councillor John Cox, as King Robert the Bruce, and one of our editorial subcommittee, as a bishop. Who says embarrassment is dead?

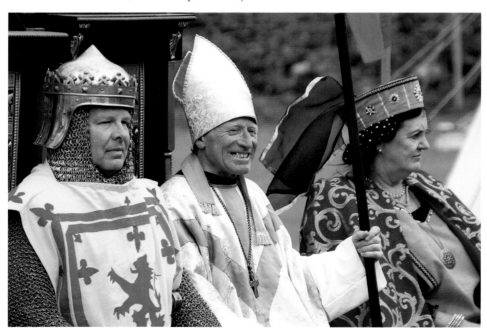

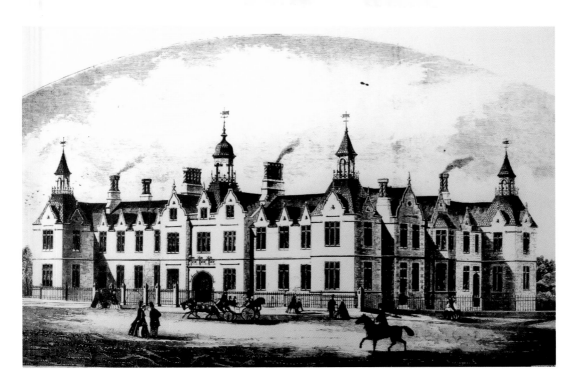

## Chalmers Hospital

The Chalmers Hospital was a gift to the town, a fine single-minded piece of fake Jacobean architecture from 1861. The town fought to retain it recently, and the modern picture shows the entrance to the new wing, single-minded in a completely different style. The old picture is not actually a photograph, and it might be worth comparing the details shown with a historic photograph, like the old photograph on page 72.

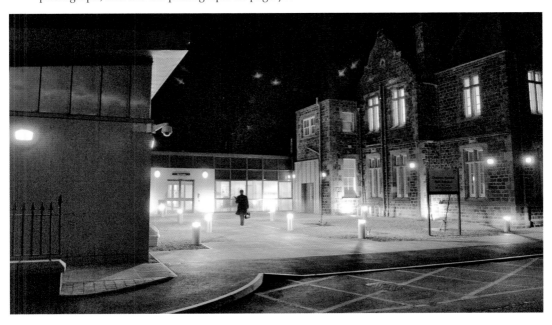

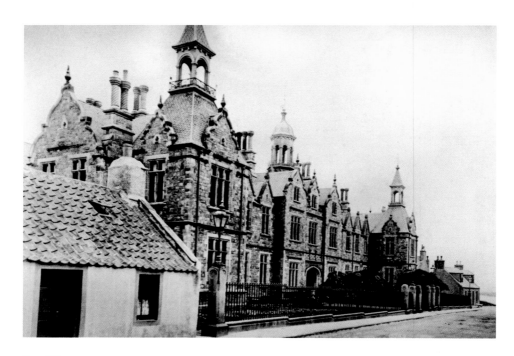

## Roof Turrets

Past and present sometimes look identical, and then you realise there is something missing. Fancy roof turrets cost money to repair, and perhaps have no real purpose. But what a pity that some of them have gone! Hospitals have this habit of adding little extensions that they think you won't notice. The old railings were rather grand too.

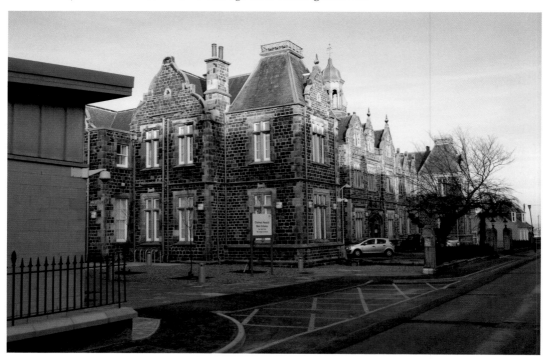

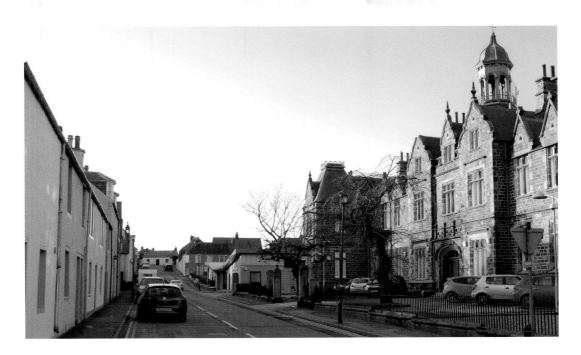

## Clunie Street and the Hospital

The new hospital buildings, with their low slopes and with almost nothing vertical, are completely different in spirit from the old one. They replace humble cottages, alongside which the old hospital looked very grand and different. They also replace, around the back, the 1952 maternity wing, which was flat-roofed and in a Mediterranean style. It was a very modern statement in the 1930s, but unsuited to our climate.

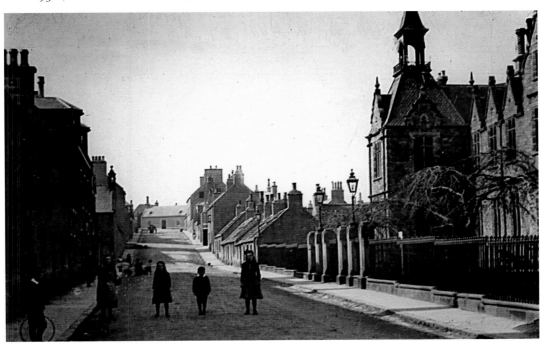

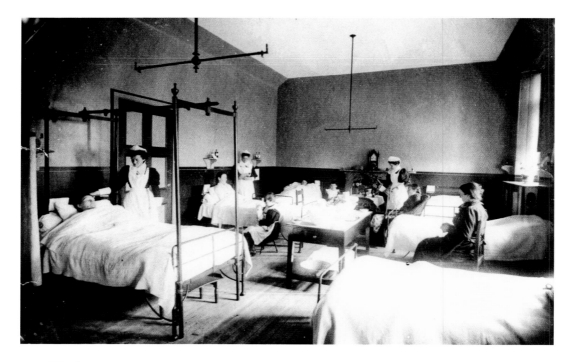

## Wards Then and Now

Here we see wards then and now. Then relative privacy would be arranged by screens; now people are in separate rooms. The nurses wore complicated costumes that didn't look comfortable then, but now all is different. Would there have been any problem then in taking a photograph of a working ward? Nowadays you are grateful to be allowed to photograph an empty bed.

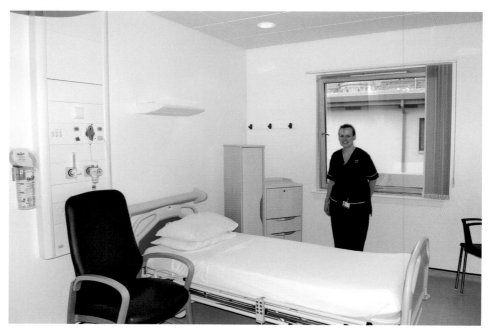

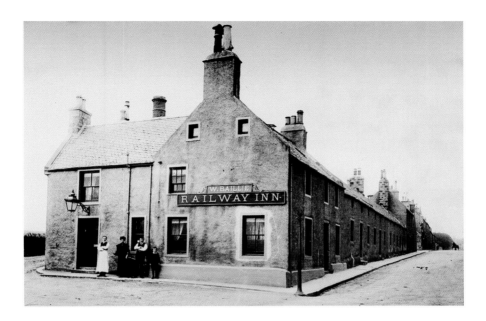

### The Railway Inn

Twenty miles from the nearest station, this is still the Railway Inn. Of course there used to be a station just down the hill. Indeed, from in front of the pub you can see two other former stations across the river, at Macduff and Banff Bridge. This was a favourite watering hole for airmen from RAF Banff at Boyndie during the Second World War.

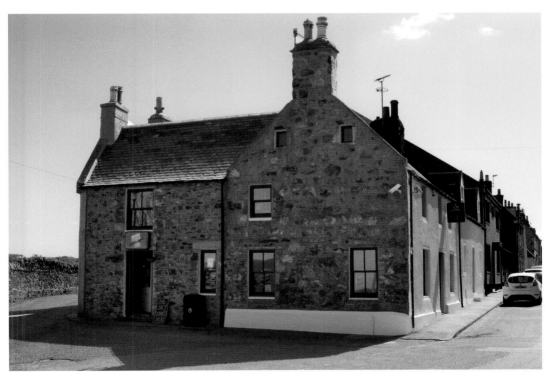

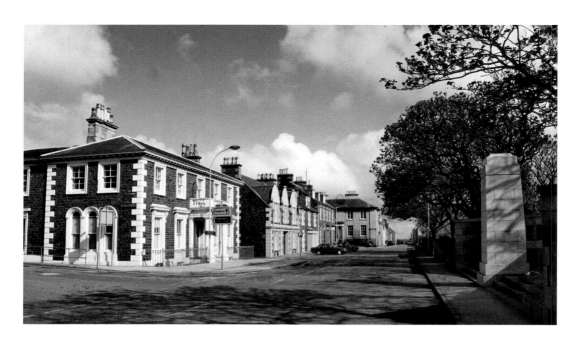

## Victorian Banff – Castle Street

Fashions change in the exterior decoration of houses. This fine row of Victorian villas on Castle Street has now heightened the colour of the edgings, in a way common in the fishing towns along the coast. There seems to be more use of harling, which, if lime- rather than cement-based, is kinder to the stone. The buildings themselves are basically unchanged. The war memorial of 1922 is on the right.

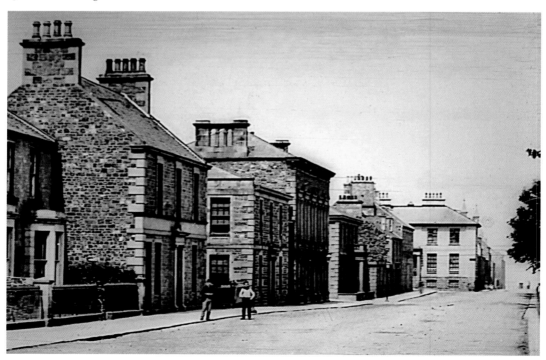

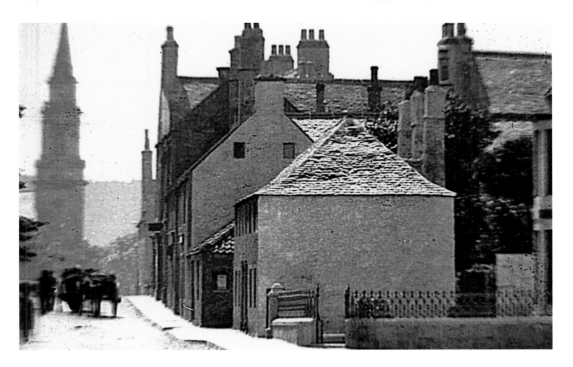

## Castle Street, Looking South

There was a big block of buildings here on Castle Street, and, though we can place them by the steeple, there is nothing else we would recognise, as they were demolished. The building in front, with the piend roof (no gable end) and the row of very tall chimneys at one side, is intriguing. Their 1960s replacements, all useful shops with a nice coffee room, are architecturally dismal.

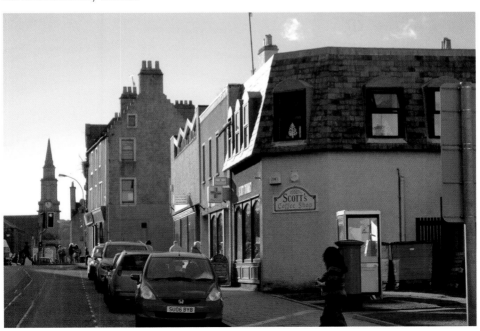

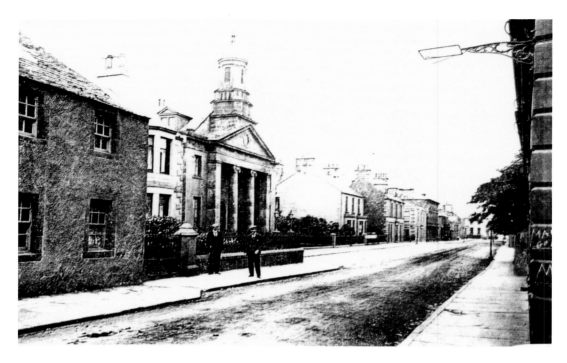

## Trinity and Alvah Church

Here is a story with a happy ending. When the Church of Scotland split at the Disruption of 1843, the parish minister went out to found Banff Free Church, the fine classical building we see here. After the churches united again this building was redundant. Plans fell through to turn it into a library, and it was mouldering away. Now the Harvest Centre is restoring it as a church.

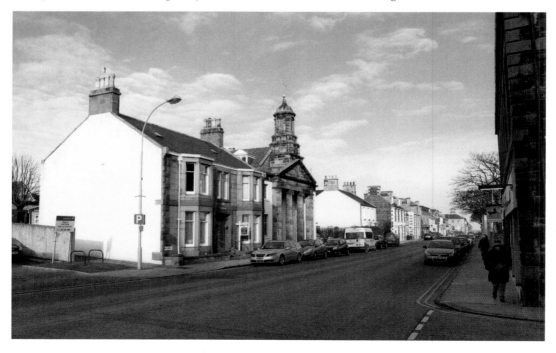

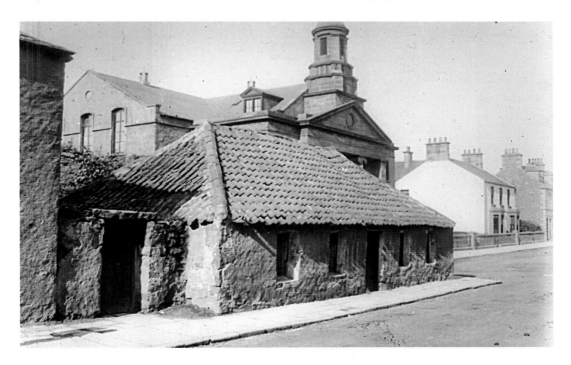

### Two Old Post Offices

Sticking even further out into the roadway of Castle Street than its neighbour, this one-storey building was demolished even before the historic photograph on the previous page was taken. This was the original post office of Banff, and for our modern picture we show its successor, a jolly Edwardian building on Carmelite Street, where we still go to collect parcels. The present post office is only a few yards west from the original one.

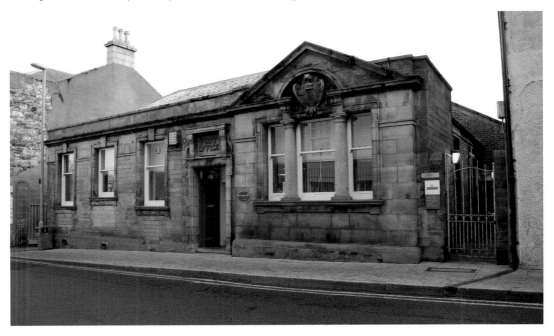

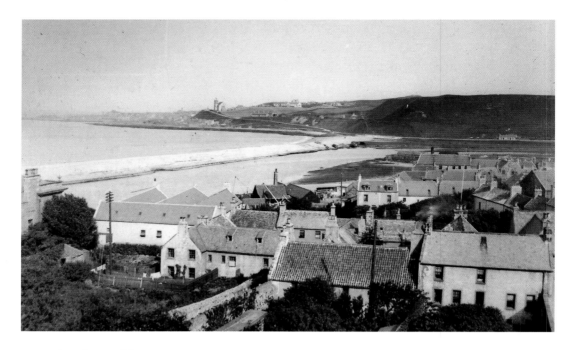

### View from Old Castlegate

Banff is on two levels, so here, from upstairs in Old Castlegate, we are looking over the back of the houses on High Shore. You can pick out in both pictures the crow-stepped gable of Ingleneuk. There is a good view of the back of the old manse, now replaced by council housing. Macduff, from this distance, seems little changed apart from the war memorial tower, built in 1920.

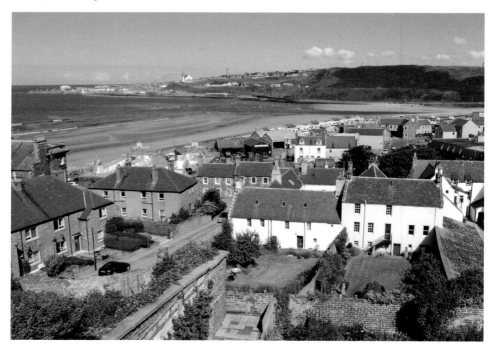

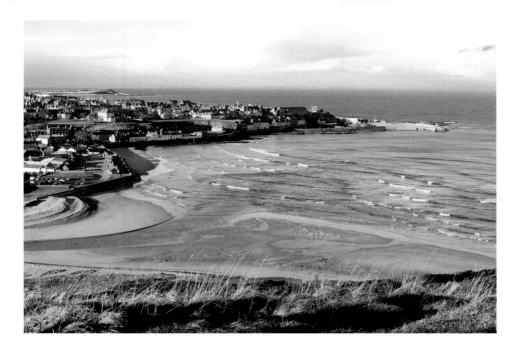

## Mouth of the Deveron

For hundreds of years, the mouth of the Deveron had a great shingle and sand bar across it. This meant that in the early days, boats could shelter in behind it, before ever Banff had a harbour. The river swung to the west and lapped against Deveronside. The whole shingle bank was removed by bulldozers and diggers in 1942 to build the runways at RAF Banff, a very active Coastal Command strike base.

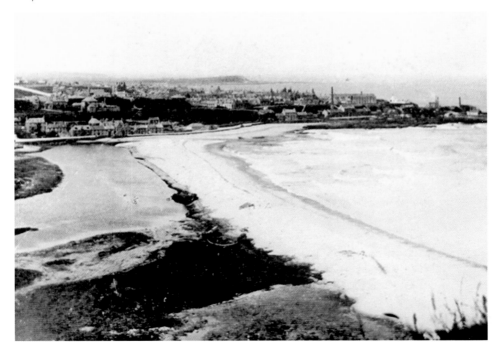

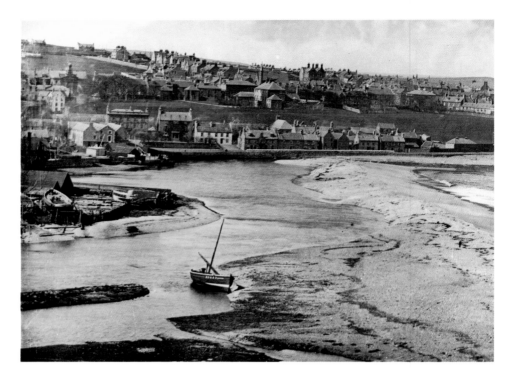

### On the Shore of the Deveron

In the days of the bar, you could leave a fishing boat behind it safely. On the opposite bank we can see a boatbuilding yard. Robertson's Granaries seem conveniently close to the river. The modern photograph places the bridge in context, and shows the site for travelling people. We have lost the 'Stinkin' Lochie', which was where the car park is beyond the Greenbanks and before the stoneworks.

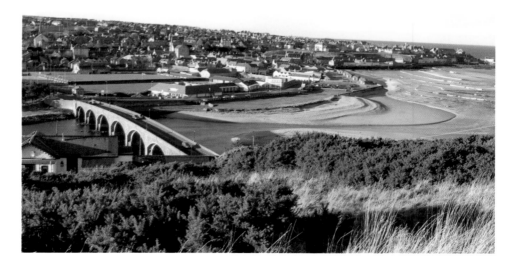

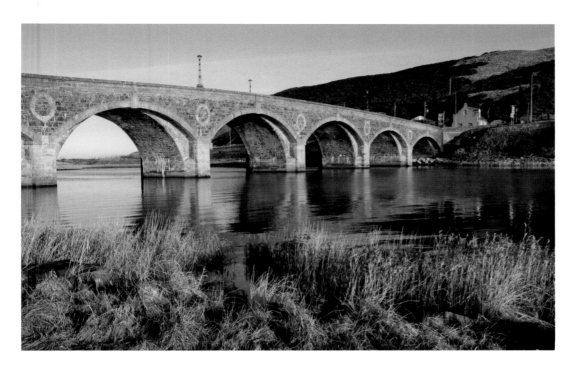

## Curling on the Deveron

This famous scene does not prove the case for global warming, but no one lately has held a curling match on the frozen Deveron. The bridge is recognisably Smeaton's design of 1779, though in fact both pictures show it after it had been widened in 1881.

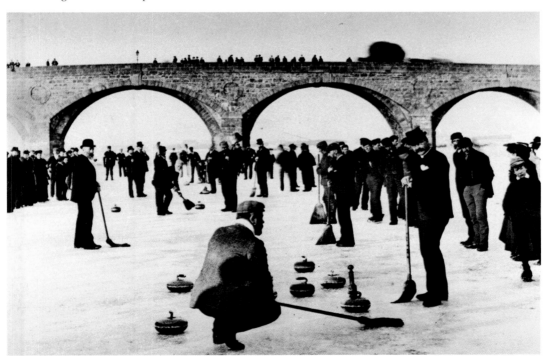

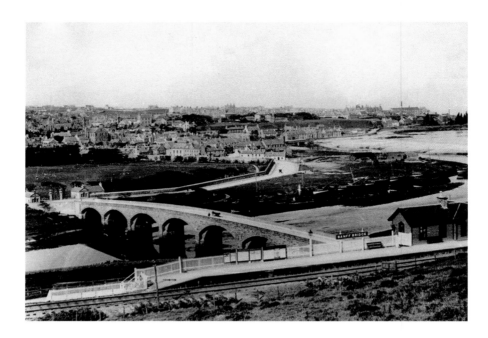

### Banff Bridge Station
In the foreground is the old Banff Bridge Station. The gates into Duff House grounds (strictly speaking one gate and a copy) are now at the entry to Banff Castle. The Greenbanks, the open space on our right as we cross the bridge, was, and is, the place for travelling fairs. The pity is that the Duke of Fife left the fine gardens beyond the bridge to the town. Perhaps it was right to build Airlie Gardens or to lay out Deveronvale football pitch, but is it right to hand over the Canal Park to Tesco?

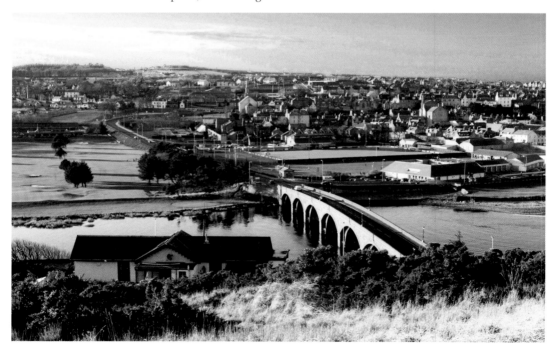

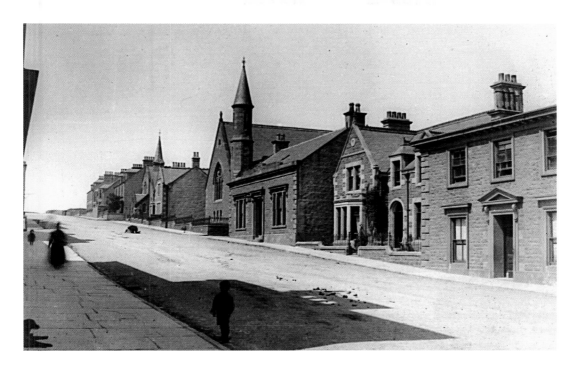

## Seafield Street

There's a missing church and heavier traffic on Seafield Street, though most of the buildings on the lower end of the street are still there. The United Presbyterian Church, Banff's third Presbyterian option, was moved stone by stone to become the parish church at Whitehills along the coast. The YMCA (Young Men's Christian Association) is now the Boys' Brigade hall – perhaps improving organisations have more hope of success with a younger group.

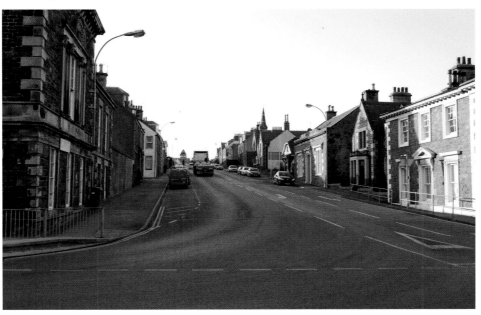

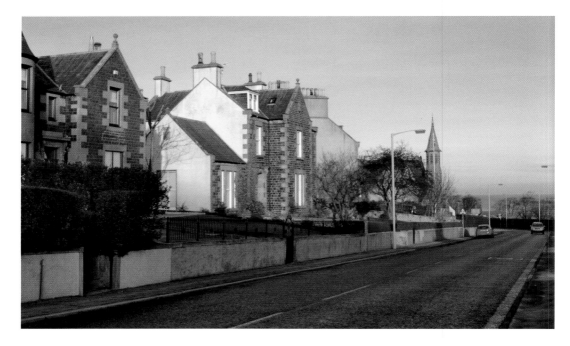

### Sandyhill Road

Here are two fine Victorian villas and the Roman Catholic Church of Our Lady of Mount Carmel on Sandyhill Road. It does look as if the outskirts of urban development, as this then was, were something of a wild frontier. In time they will dig out a pavement to match the rest of the road. The horse is clearly standing still, presumably for the photograph, in the middle of the road. You wouldn't try that now.

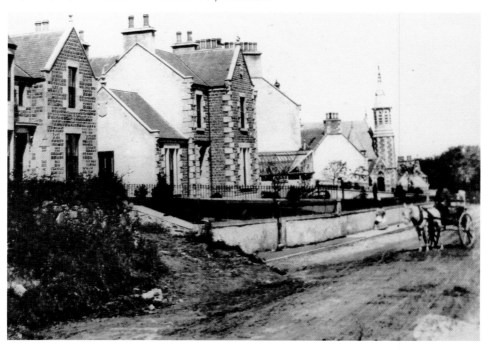

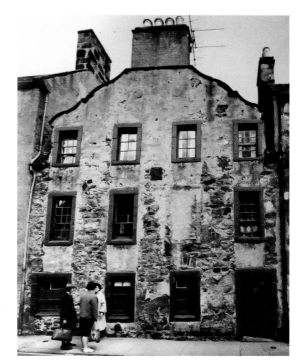

### Boyndie House

Here is a before-and-after of the restoration of the admirable Dutch-influenced Boyndie House of 1740 on Boyndie Street, next door to the Town and County Club. When you see the original picture do you feel that this building 'must be preserved at all costs'? And do you feel, looking at the later picture, any nostalgia for the pleasing decay that went before?

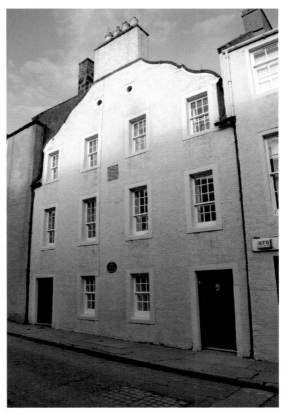

87

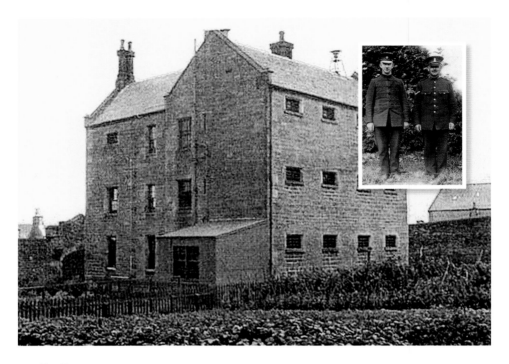

### Banff Jail

This bleakly functional building was the Banff jail, and the inset shows its officers. Part of the site has been used for another emergency service, the fire station. The only decorative piece of the original jail was a pair of crenellated turrets, which have been retained on the corners of Turnkeys, a modern housing scheme on Reidhaven Street.

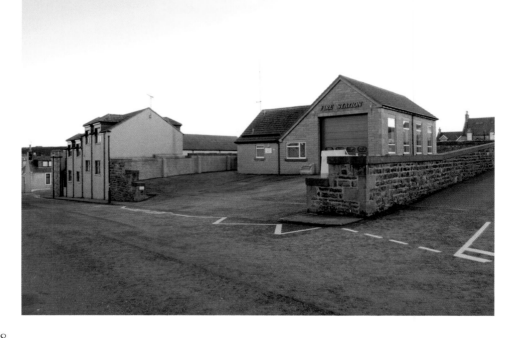

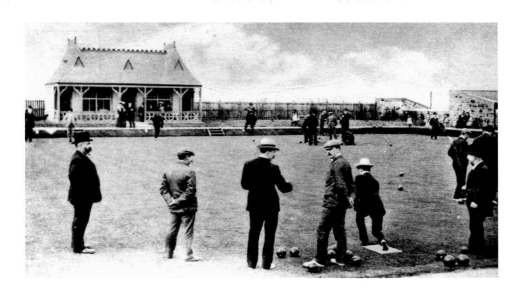

## Banff Bowling Club

This is Banff Bowling Club, then and now. The green seems identical, though the mowing pattern has switched to a diagonal. There is a grand new pavilion, and more women seem to be involved. There is a very fine range of men's headgear in the older photograph.

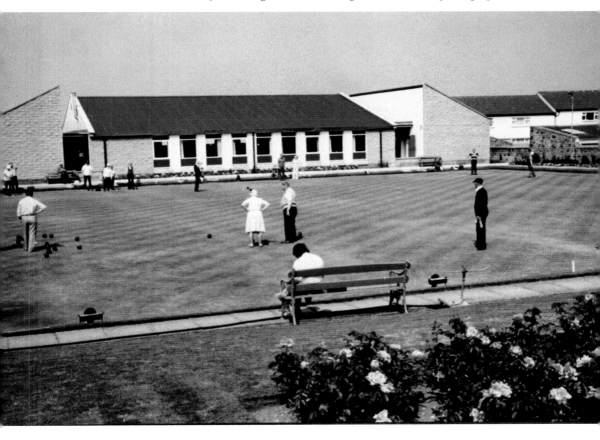

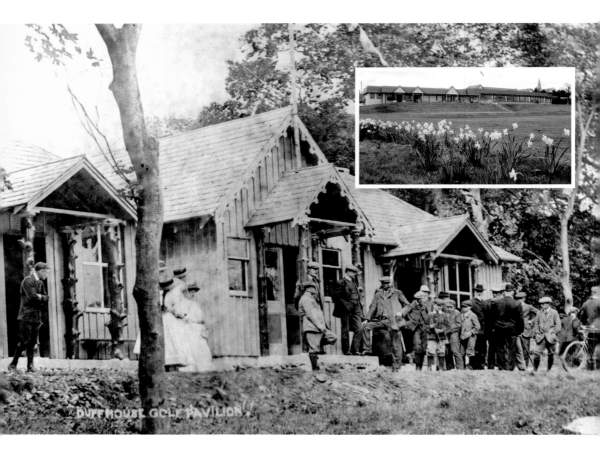

## Golf at Duff House

Golf at Duff House has gone from strength to strength since the club was founded in 1910. It became Duff House Royal in 1923, at the request of the Princess Royal, who was Duchess of Fife. The original pavilion, looking like a chalet in the woods, has been replaced by the present large and lavish clubhouse.

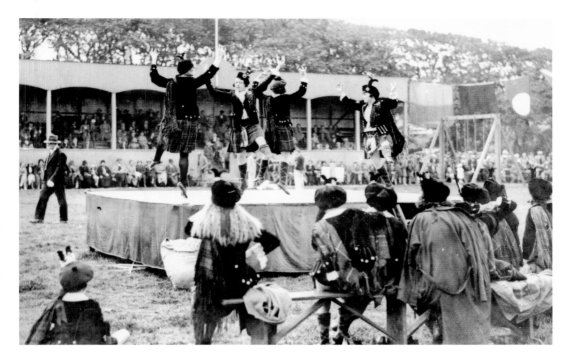

## The Princess Royal Park (or Highland Games)

Banff is not a Highland town, though the name is probably Gaelic. You can have Highland Games anywhere in Scotland, and here we have dancers performing what looks like a foursome reel at the Banff Highland Games, which no longer happen, but might return. For a twentieth-century spectator sport we have football, with Deveronvale in the Highland League (so in one sense Banff is Highland) since 1938.

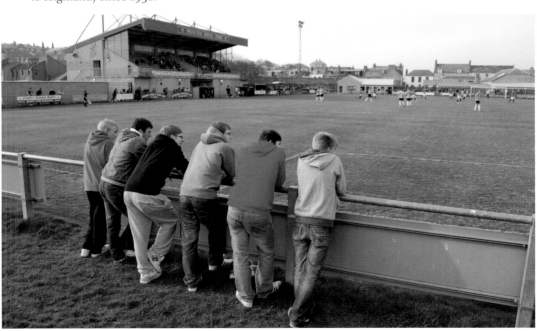

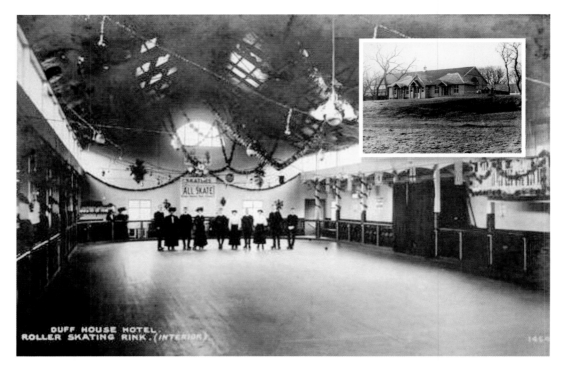

DUFF HOUSE HOTEL
ROLLER SKATING RINK. (INTERIOR).

## Banff Had a Roller-skating Rink

The present golf pavilion incorporates its predecessor on the site. Behind that there once stood the Duff House Hotel roller-skating rink. From the inset you can see, by comparing the windows inside and out, that this large wooden building stood where the car park now is. If there is any picture in the book that one might wish were a movie instead, it is the one of that line of roller skaters.

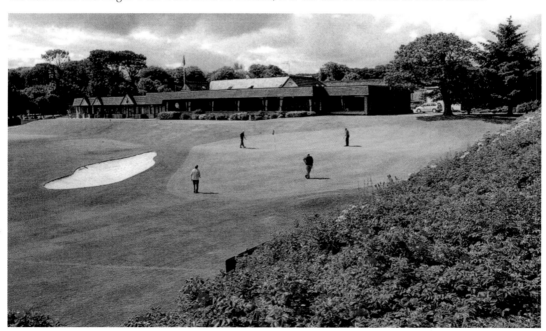

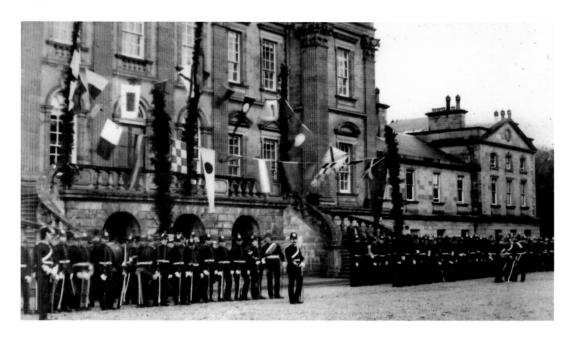

### Duff House Military Ceremonies

Duff House is a wonderful backdrop for military ceremonial. The first group, we think, are volunteers. What is the language of the flags? There is a good view of the Victorian wing, which was destroyed by a German bomb in the war. The 1994 photograph is of the last 'beating the retreat' carried out by the Gordon Highlanders before they were disbanded. The tall man with his back to us on the left is James McPherson CBE, Lord Lieutenant of Banffshire, and a deeply missed former Vice President of the Banff Preservation & Heritage Society.

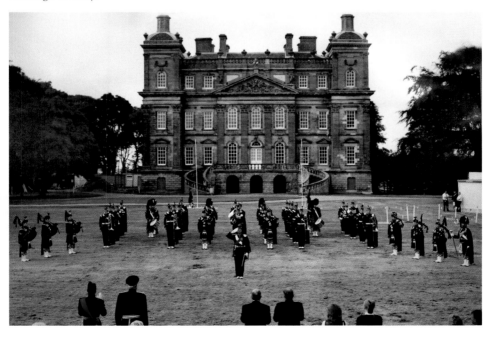

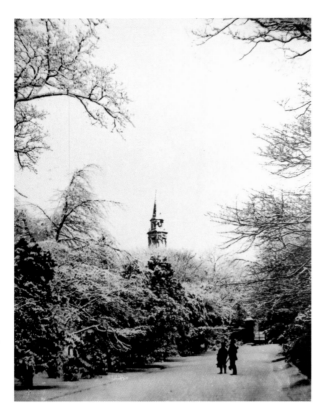

### The Approach from Duff House

This atmospheric view is the drive
from Duff House to the Collie
Lodge, with the spire of Banff
parish church showing through
the trees. Since then, though there
is still such a drive, it meets the
bypass and the St Mary's car park,
which are less atmospheric. Every
building visible in the modern
picture is worth looking at, but
tarmac and cars do rather diminish
the view.

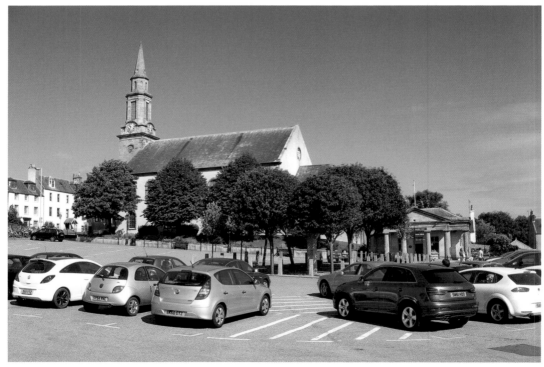

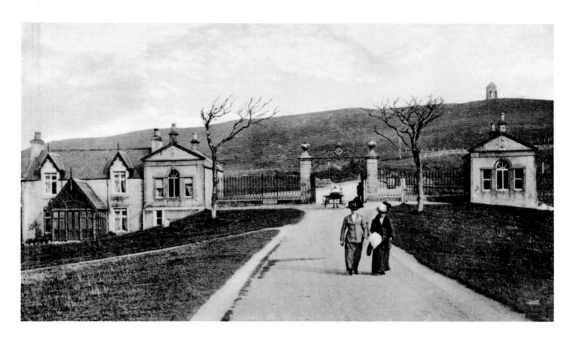

### Main Entrance

Here is the main entrance to Duff House, with its two lodges, the gates, now at the castle, and the bridge straight ahead. There is an appropriate amount of traffic, two ladies out for a stroll, and a horse-drawn vehicle. We have changed all that. One lodge has disappeared, the other is rather a pathetic remnant, the gates have gone, and the traffic thunders up the hill, though our canny photographer chose a quiet moment. The Temple of Venus is still there on top of Doune Hill.

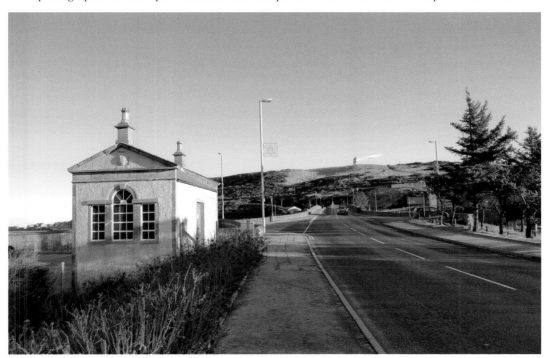

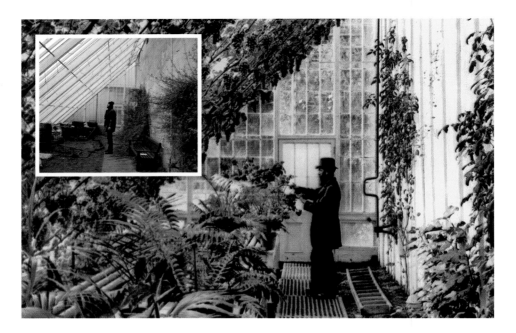

**Duff House Vinery**
In the gardens cut off from the house by the bypass, the Duff House greenhouse still stands. Something is definitely flourishing there in the old photograph, and the gardener is really quite formally dressed. The greenhouse still has potential, and there is the Chairman of the Banff Preservation & Heritage Society!

# Acknowledgements

The Banff Preservation & Heritage Society subcommittee responsible for compiling this book consisted of Dr David F. Clark, Henry J. L. Mantell, Dr Alistair Mason and Julian Watson.

We are indebted to those who allowed us the use of their images of Banff, to Bill and Ian Bain of Bodies of Banff; to Aberdeenshire Council for those old images of Banff appearing on pages 5, 7, 14, 24 (inset), 25, 29, 50, 61, 65, 66, 68, 69, 82, 86, 92 (inset), and 94, and the front cover, which are copyright of Aberdeenshire Council and reproduced by permission of Aberdeenshire Museum Service; to the Scottish Field and to Ronald Bell, Bob Carter, Elizabeth Gabriel, Jim Mackay, Harry Mantell, Ian Rennie, Ian Strachan and Elizabeth Strath. Several of the images were also taken from Banff Preservation & Heritage Society's own collection.

Most of the 'new' images of Banff were taken by Dr David Clark, Henry J. L. Mantell and Julian Watson, while Dr Alistair Mason drafted the text.

Our apologies go to any other contributors whose names we may have inadvertently omitted but to whom we are most grateful. We would like to thank the team at Amberley for their skill, help and patience.